JUN 2006

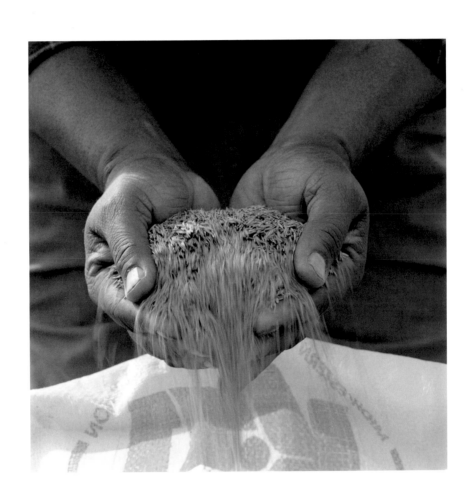

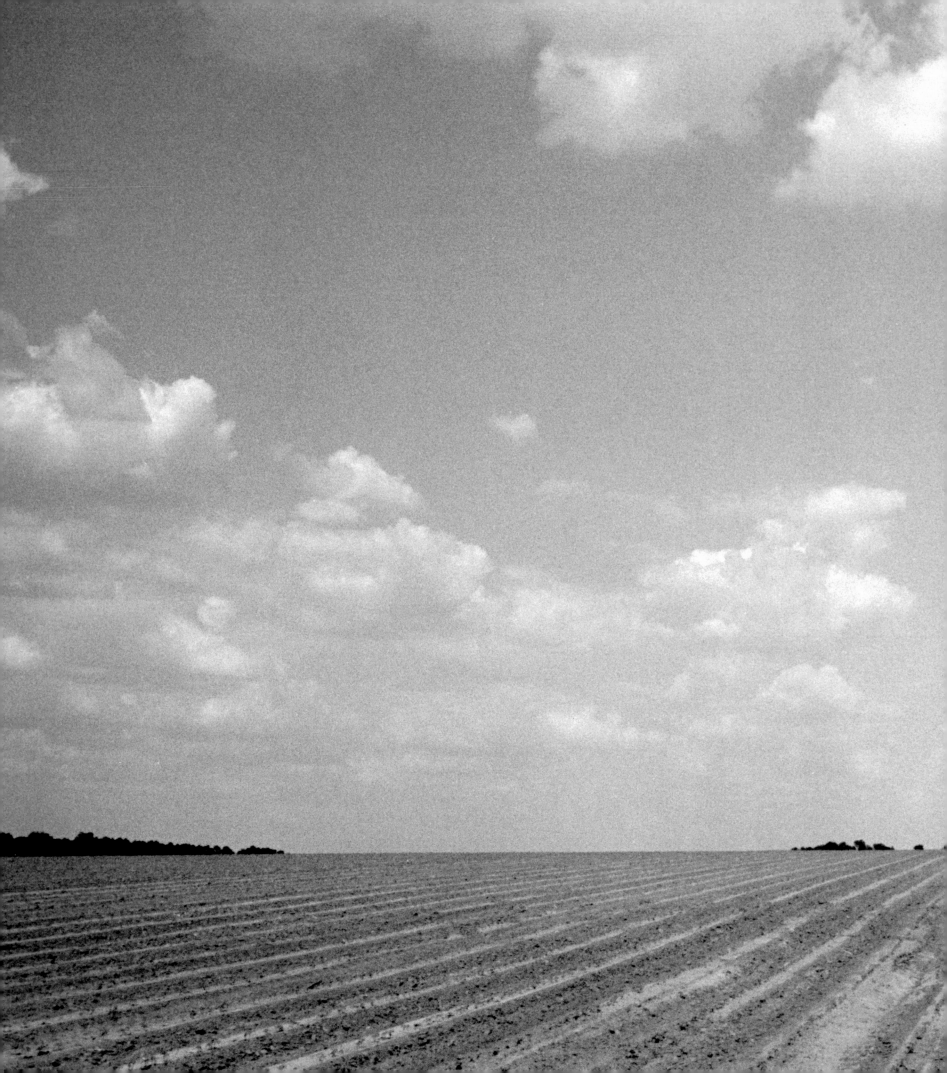

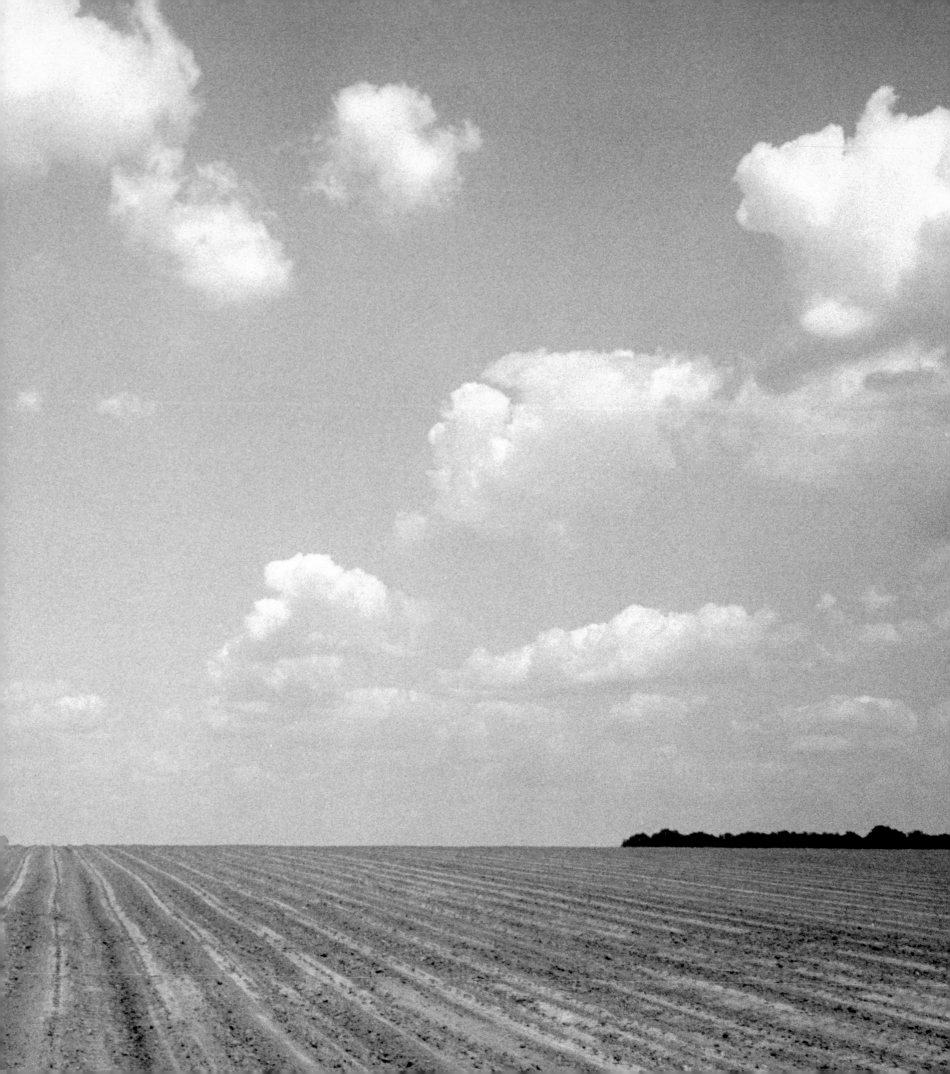

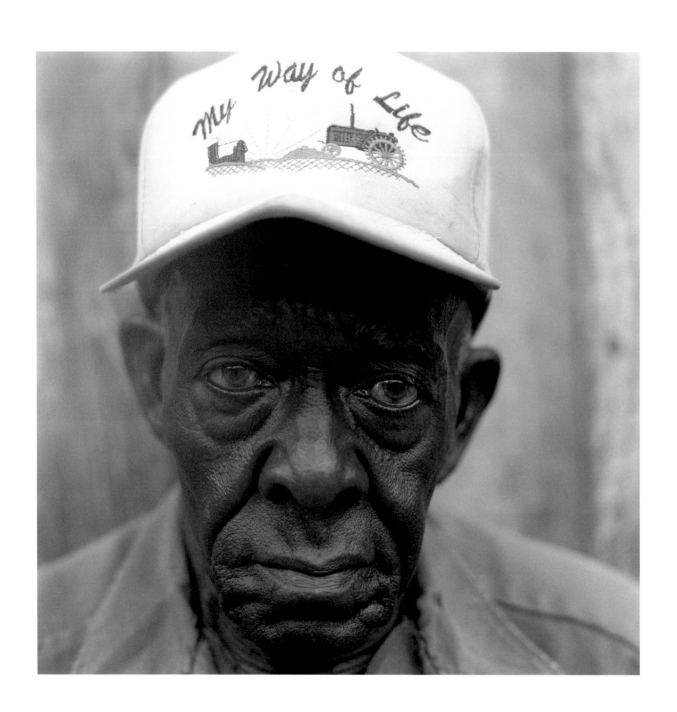

Black Farmers in America

PHOTOGRAPHS BY

JOHN FRANCIS FICARA

ESSAY BY JUAN WILLIAMS

THE UNIVERSITY PRESS OF KENTUCKY

For Christian and Francesca

~~~~~

Publication of this volume was made possible in part by a grant from the
National Endowment for the Humanities.

The University Press of Kentucky
Scholarly publisher for the Commonwealth, serving Bellarmine University, Berea
College, Centre College of Kentucky, Eastern Kentucky University, The Filson
Historical Society, Georgetown College, Kentucky Historical Society, Kentucky
State University, Morehead State University, Murray State University, Northern
Kentucky University, Transylvania University, University of Kentucky, University
of Louisville, and Western Kentucky University.
All rights reserved.

Editorial and Sales Offices: The University Press of Kentucky
663 South Limestone Street, Lexington, Kentucky 40508–4008
www.kentuckypress.com

Book design by Brady McNamara

06 07 08 09 10  5 4 3 2 1

Library of Congress Cataloging-in-Publication Data

Ficara, John Francis, 1951–
Black farmers in America / photographs by John Francis Ficara;
essay by Juan Williams.
p. cm.
ISBN-13: 978-0-8131-2399-8 (hardcover : alk. paper)
ISBN-10: 0-8131-2399-2 (hardcover : alk. paper)
1. Farm life—United States—Pictorial works. 2. African American farmers—
Pictorial works. 3. Farm life—United States—History.
4. African American farmers—History. I. Williams, Juan. II. Title.
S521.5.A2F53 2006
779'.96308996073—dc22
2005031060

This book is printed on acid-free paper meeting the requirements of the American
National Standard for Permanence in Paper for Printed Library Materials.

Member of the Association of American University Presses

Manufactured in the United States of America.

# Contents

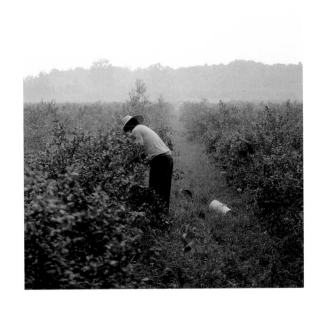

"One time we were making a good living farming. Today, farmers need big acres to survive. Small farms are now a thing of the past, even though small farms are important to the economy."

**HAROLD WRIGHT**  BLADEN COUNTY, NORTH CAROLINA

How do you take a picture of the last moment of twilight?

Quickly! Take the photograph before that last light fades away for all time. Be careful as you take the pictures. What you capture with your eyes will have the last say on our memories.

Here are John Ficara's masterful images of a modern version of "twilight's last gleaming"—what is left of America's heritage of strong black farmers. These photographs are taken with the care required to preserve a precious American heritage. American history is on view here. These are deeply felt memories. There is much sweetness in these pictures but also a trace of bitterness. Today, all that remains of the nation's black farmers is a few older folks working the same rich, dark southern soil as their forefathers.

≈≈≈≈

Just as slavery is now long gone, today's black farmers are on the edge of disappearing past twilight into darkness. Now John Ficara's photographs preserve their image—the distant echo of so much that has gone before. The beauty of these pictures is in the wealth of memory. It is also in the strength of the few black farmers still at work. They are now touchstones of all American life, like the patriots of the Revolutionary War; the cowboys of the Old West; or the trailblazers who settled the Pacific coast.

Images of the emotional faces and determined eyes of the few black farmers who remain today evoke America's original sin—slavery—and its aftermath, sharecropping, liens, and peonage. Every image takes us back to the not-too-distant days of Jim Crow segregation.

Each photograph articulates the paradox facing black farmers: what looks like slavery is, in fact, the most courageous form of economic self-determination, and what looks like "the simple life" is, in fact, a profoundly complex and risky economic undertaking. Planting and harvesting, crop rotation, fertilizers, pests, insecticides, drought, pricing vagaries, Cleveland Jackson's decrepit sugarcane harvester, replaceable only at a cost of well over two hundred thousand dollars—there is little here that can be called simple. And now, at the start of the twenty-first century, that golden legacy of black farmers has all but faded to silence. Only faint light and distant echoes remain—very few black farmers still working their acres, like brave warriors in a battle with economics and racism that they refuse to lose. These heroes remain as a reminder to the nation of so many others who were pushed off their land or gave up when they could not get loans or subsidies. And it was not only a lack of money that handicapped them. Black farmers often did not get the expert help they needed to succeed as farming became a business of chemical fertilizers, crop rotations, and foreign markets. The beauty of these remaining black farmers, their strength and power, is now

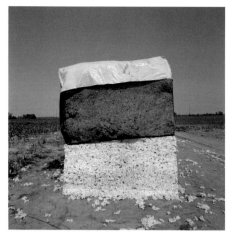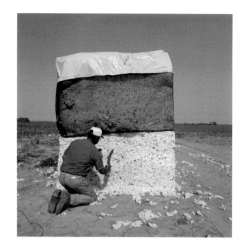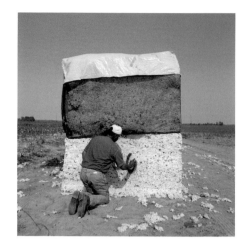

EDMOND CLARK SPRAY PAINTING COTTON MODULE. HUMPHREYS COUNTY, MISSISSIPPI

down to a precious few. Their every remaining moment hangs in the air like an echo.

As each small farm depicted here is abandoned or sold off, more than the land is lost. The idea of the strong black family reaches back to the days immediately after slavery ended. The best black families shared in the struggle to survive, to accumulate wealth and advance as the equals of white people. This is the same idea behind the kibbutz in Israel and the youthful communes of the 1960s. The black farm is a symbol rich in these democratic ideals even today. It is a Garden of Eden in the African American memory where the first freed black slaves, after the Civil War, worked to regain the humanity that had been robbed from them in slavery. This deep memory is at the core of the black experience. And yet, as more and more black farmers disappear, the reality of the black farmer is fading. What we see today are only faded images and echoes.

Among the black farmers pictured here are people determined to continue their family tradition. Their struggles will be arduous, but surely no more arduous than the long road from slavery, to forty acres and a mule, to putting four children through college on farm income, as James Davis Sr. was able to do in the 1950s and 60s.

## FORTY ACRES AND A MULE

Old, tangled roots tie black Americans to the nation's farmland. Black labor on Southern plantations formed the backbone of the nation's first economy, an agricultural economy. Slave labor provided the cheap cotton that set in motion the textile factories at the beginning of the industrial age and the rise of the American economy to the best in the world.

With the end of slavery, freed blacks began a struggle of biblical proportions to gain land and enjoy the same economic rewards as whites. At the heart of that gospel lay the failed promise of "forty acres and a mule," which had its genesis in General William T. Sherman's Special Field Order Number 15, issued on January 16, 1865. The general's command allowed former slaves to begin farming on land abandoned by fleeing Confederate soldiers. In March of that year, Congress authorized General Sherman to rent out the land and supply as many plow mules as possible to the new farmers.

At that time, life for most of the four million freed black people was desperate as they pushed away from the South and slave plantations with no clear idea of where to go and often with no food. In the words of abolitionist Harriet Tubman, "I was free, but there was no one to welcome me to the land of freedom—I was a stranger in a strange land." Many of the former slaves eventually returned to their old plantations, their spirits broken. They resumed working as field hands on farms, laboring under the same conditions as they had when they were slaves.

In this atmosphere of fear, poverty, and confusion, the promise of "forty acres and a mule" was seen as a sign of God's own deliverance. The offer created a sensation among

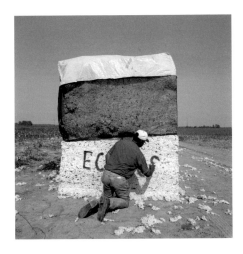 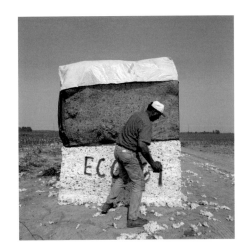 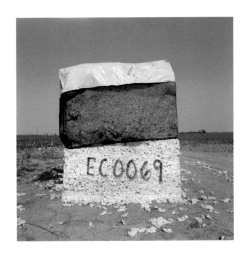

the nation's black population, which reacted as if Moses had parted the waters to the Promised Land. They could finally see a place in America where they could be self-sufficient and determine their own future. These newly liberated citizens generally had no resources or education, and farming was the one business that they knew firsthand. In the first six months after General Sherman offered the land to emancipated slaves, 40,000 black people settled on more than 400,000 acres of farmland along the eastern coast, including the Sea Islands off South Carolina and coastland in Georgia and Florida. General Sherman gave speeches trumpeting this land as a first step for freed slaves—a way to feed themselves and their families and even as a way to earn money by selling produce. As an added benefit, the rent they paid helped to support the Freedmen's Bureau.

But in May of 1865, the glimmer of hope faded even for the lucky black people who had received land and an animal with which it could be plowed. President Lincoln had been assassinated, and his successor, Andrew Johnson, ordered General Sherman to return the land to its Confederate owners as part of the effort to rebuild relations between the federal government and the defeated South. Thus, the offer of "forty acres and a mule" vanished into the status of legend, becoming a catchphrase for all the broken promises the government has ever made to black people.

## LANDOWNERS AT LAST

Despite Johnson's decree, some former slaves made a way where there seemed to be none and obtained land to farm. To them, ownership of a farm meant more than owning a business: the deed to the land signified the end of their days as slaves, as sharecroppers, as workers for someone else. It was true emancipation—no one could confuse a slave with a landowner. To be a landowner meant status as a voter, taxpayer, and citizen. Thus, possession of land represented a defiant step toward racial equality with white farmers, who had constituted the heart of the ruling class in the early-1800s southland. Now, for the first time, blacks controlled their own future and fate.

The land offered a promise to future generations, too. No matter what misfortune or oppression might come (short of God's wrath of drought and pestilence), the family could support itself—raise its own food, tend its own pigs and chickens, and pass on that security to children and grandchildren.

The farm, then, went beyond land and ownership. To a black man or woman it was a ticket to self-sufficiency, as well as a sign of having arrived in the eyes of their neighbors and themselves. The black farmer, working hard for his own, became the living symbol of the strong, independent black man. Farming also allowed black families to move into other businesses, from funeral homes to preaching to construction, and thus served as the bedrock of all black wealth in America.

## DISCRIMINATION AT THE USDA

The broken promise of "forty acres and a mule" would be compounded in post–Civil War America by the U.S. Department of Agriculture, which Lincoln had founded in 1862. The racial tensions over slavery had spread from the political arena like a fungus among the 2,500 agricultural offices that had been established in various communities to help farmers. Called the Farmers Home Administration (FmHA), these offices reflected local political power and the racial callousness of federal officials. In most cases black farmers lacked the education, money, or political connections to wield any influence in the community's FmHA branch. As a result, the Agriculture Department's own records show that black farmers' requests for help generally received scant consideration. Instead, the white southerners in charge gave first priority to helping white farmers, especially those who held large farms and were politically connected.

Fear also played a role in discouraging black farmers from seeking assistance from the local agricultural office. With good reason they worried about making their financial information available to local white farmers, many of whom stood ready to make a grab for their land and force them to work as sharecroppers or even day laborers on larger, white-owned parcels.

Today, black farmers call the U.S. Department of Agriculture the "last plantation." In 1982 the Civil Rights Commission concluded that decades of bias against black farmers by the Agriculture Department threatened to kill off the few remaining black farmers. As recently as 1997, an internal audit conducted by the Agriculture Department concluded that in the southeastern United States, loan applications from black farmers took three times as long to be processed as loan requests from white farmers. It found that blacks in need of financial support met "bias, hostility, greed, ruthlessness and indifference." Black officials at the Agriculture Department's headquarters in Washington told the *Washington Post* in the 1990s that the department continued to be a "hotbed of racial bias and harassment." They openly expressed exasperation at the difficulty of trying to change such a deeply insulated and racist system. Clearly, this fight was over more than farms. It was a strike against a sick culture festering with antipathy to people of color. This sinful history stretched back to the day President Lincoln created the Agriculture Department in 1862. Only a few months later he signed the Emancipation Proclamation on January 1, 1863, freeing four million black slaves.

## DECLINE OF THE FAMILY FARM

In 1920 more than half of all black people in America lived on farms, mostly in the South. By comparison, only one-quarter of white Americans lived on farms across the United States. That year, black Americans made up 14 percent of all the farmers in the nation and worked 16 million acres of land. By 2003, they accounted for less than 1 percent of the nation's farmers and cultivated less than .003 percent of the farmland. Today, battling the onslaught of globalization, changing technology, an aging workforce, racist lending policies, and even the U.S. Department of Agriculture itself, black farmers number below 18,000, and they till fewer than 3 million acres. Inside these statistics is a staggering story of human loss: when each farm closed, the farmer's spouse and children and grandchildren, and the people they hired, all had to leave a way of life.

Admittedly, these were tough times for all small farmers, black and white. Fifty-five percent of white farmers went out of business during the period of 1940–78, while larger, corporate farms came to dominate food production and sales. Most benefits from government subsidies and access to international markets accrued to the corporate farms, operations larger than 1,500 acres, which accounted for more than 83 percent of all U.S. farm products. The average black farmer, in contrast, was cultivating fewer than 120 acres in 1992, and half were hardly surviving on 50 acres and under. Far more often than their white peers, black farmers failed during that period of crushing economic pressure because the USDA forced them to the back of the line when every American farmer was desperate for subsidies to buffer them against changes in the farming business.

Between 1985 and 1994, black farmers—47 percent of whom had gross sales under $2,500—averaged only $10,188 in yearly subsidies, less than a third of the average support payments given to white farmers, who were grossing almost four times as much in sales.

Barely making a living and often working their small piece of land to the point of depletion, many black farmers sought to buy improved seed, better machinery, or additional acreage to maximize their yield. But they lacked the necessary collateral in the form of land to secure loans from commercial banks, some of which were run by segregationists. And when the government, the final safety net, denied black farmers' requests for loans or subsidies, their only option, in the words of the Civil Rights Commission, was to risk losing all by taking out personal loans at usurious interest rates. And it was not only a lack of money that handicapped black farmers: they seldom received the expert advice needed to succeed as farming became a megabusiness.

## GARY GRANT

Many black farmers literally died trying to hold their ground against these corrupt social forces. It is a story all too familiar to Gary Grant's family, who initiated the longest-running lawsuit against the Agriculture Department. The Grants owned one of the larger and more successful farms, black or white, in Halifax County, North Carolina. Despite storms and drought that had bedeviled the area for three years, the Grant farm was still somehow making a go of it until the government denied loans to the family. Without the loans the Grant farm went into foreclosure. At that point, Grant's parents, Matthew and Florenza, sued the former Farmers Home Administration, now the Farm Service Agency, for racial discrimination: of the twelve farm families denied loans, ten were black and two were white.

Grant, fresh out of college at the time, remembers the emotional puzzle of watching loan agents tell his father, a farmer who had survived all manner of natural disasters, that he didn't know how to till the land. Grant and his five

siblings, also in disbelief at what was happening, had made the difficult trek into the loan agency to support their father. But the show of family support didn't matter. The loan was still denied. "The day we sat and watch my father be told that there was nothing he could do, that was the worst. He was an honest man and a good Christian, all he wanted to do was pay his debt," Grant reflects. "It didn't make any difference who he brought in to help, they were going to sell him out, an officer told my father."

Later, the Agriculture Department attempted to foreclose with a brutal force that still chills the Grant family. In the early pre-dawn hours, the family heard six eighteen-wheelers approach the farm to remove all its equipment. Almost every marshal in the county accompanied the agricultural officials. The sight of the county's most successful black farmer losing his machinery attracted the attention of local television crews. The story was simple: the Grants were fighting the U.S. government for their farm's survival. The family never did quit the fight. Eventually the federal government offered a monetary settlement, but the family refused, saying the offer was simply too little and too late. In 2001, Grant's parents passed away without ever seeing a dime from the government.

## THE BLACK FARMERS AND AGRICULTURALISTS ASSOCIATION

With his parents' death, Gary Grant stepped up his crusade to educate black farmers about their rights. Some had been afraid to be seen with the Grants because of their lawsuit against the U.S. government; still others were held back by their own superstitions (many older black farmers were afraid even to write their wills because they thought that doing so might lead to their death). All of these factors—lack of information about rights, fear, and superstition—combined to accelerate the demise of black farming. Denied the government aid that was rightfully theirs, black farmers were forced to sell off to large corporations and move their families to the city.

Grant decided there was strength in organizing black farmers, and he founded the Black Farmers and

Agriculturalists Association. In 1997, over one thousand black farmers demonstrated their collective power when they banded together to file suit against the USDA, alleging racial bias in the government's procedure for distributing farm loans and subsidies between 1981 and 1996.

The lawsuit added to black-white tension in many southern communities. After one black farmer joined the court action, all the white people in his town stopped talking to him. "Everyone thinks we wanted something for nothing," he said of white neighbors who thought nothing of allowing his business to fail for want of fair treatment but resented his decision to fight for his farm. They charged he was playing the race card, as if race had nothing to do with the predicament of black farmers. Indeed, some black people in those small southern towns questioned whether the lawsuit's direct challenge to the system might lead to Ku Klux Klan–style retribution. So tense was the situation that Reverend Joseph Lowery, former head of the Southern Christian Leadership Conference and once an aide to Dr. Martin Luther King Jr., hailed the black farmers who brought the lawsuit as heroes as daring as the bravest American pioneers. The detailed charges they outlined in the court case, Lowery said, also sent an important "message to the nation that the good ol' boy network is still alive and sick as ever."

In 1999 a federal judge found that the suit had merit and ordered the USDA to pay millions in claims to the black farmers. Under the settlement, black farmers who could prove that they were denied loans because of racial bias were eligible to receive $50,000 and have some taxes and debts forgiven; those able to show extensive damage were eligible for even larger settlements. Three years later, nearly 13,000 black farmers had been paid $623 million, and loans worth more than $17.2 million had been forgiven.

But another 8,500 black farmers, or 40 percent of the claimants, had their requests for financial settlements rejected. And judges for the U.S. Court of Appeals said that the plaintiffs' lawyers, who had been paid $15 million in fees, had created a "double betrayal" by often failing to meet deadlines and improperly filing legal papers so that many farmers who should have shared in the settlement received nothing. Those who did make it past the lawyers and over the bureaucratic hurdles often found that the one-time payments were too little to keep them going. Too many of the farmers were too far in debt and still lacked the credit or subsidies needed to succeed. Even the historic settlement with the government—compensation for all their pain and loss—often proved to be just another nail in the coffin of black American farmers.

## THE YOUNG PEOPLE HAVE LEFT

Today, so few black farmers remain that they are a rarity, specks of gold in a mine stripped bare long ago. The solitary, hard-pressed farmer still defiantly working his land has wrinkles not only from worry over money but from age: the young people have left. By 1994, 94 percent of the black farmers remaining were over thirty-five years old, and 35 percent were over sixty-five. The people now remaining on the land demonstrate a fierce attachment to farming as a way of black life. One-half of those with their hands still covered in the good earth a decade ago said farming was their principal occupation despite the low wages. Congresswoman Eva Clayton, a North Carolina Democrat, once told reporters that most of the remaining black farmers are "farming out of tradition, now—not to make a living." Black people are no longer even the biggest minority group in the American farm business: Native Americans hold that honor, with 87 percent of the farmland operated by American minorities now in their hands.

## ROSA MURPHY

In the summer of 2005, ninety-one-year-old Rosa Murphy looks like a ghost from the past of black farming as she sits on the porch of her farmhouse in Brooks County, Georgia. With a visitor standing by she sorts vegetables, looking for the good ones. As a child, Rosa rode bareback across the farm where her parents worked as sharecroppers. When she married Eddie Lee, a fellow child of sharecroppers, they shared a yearning to own land that they and their families had bled and sweated upon for generations. In 1938 the couple took great pride in buying acreage that had been

worked with slave labor; now it instead held a promise of prosperity and happiness that could be passed on to their descendants. At home she was surrounded by family and neighboring black farmers who supported each other through hard times. "We may not have been the most well off, but at least we always had plenty of food," she recalls.

Murphy never imagined that way of life would disappear so quickly. Sadly she tells a visitor that her neighbors, her children, her grandchildren have all moved away from the land. Of her twelve children who were born there, only four even remain in the county. When family and friends visit, they can't understand her abiding attachment to the land. "It's real sad to see how people have almost stopped even trying to farm," she says. And with the farm's irrigation system damaged by lightning, little hope remains for Murphy to make money as a farmer. She doesn't even think about asking the government for money to rebuild the irrigator. As she puts it, no one is going to give a loan to an old woman like her. All she wants is to pay off her bills before she dies. A religious woman, she prays to the Lord for help every day. "It was more than just love with the land, it was a livelihood. It was my life," Murphy whispers.

〜〜〜

Today's remaining black farmers, unwavering in their determination to cultivate their own land and master their economic fate, open our eyes to the past as well as to the future. John Ficara's photographs afford us a unique angle for understanding why slaves freed after the Civil War sacrificed everything to buy land and become independent farmers. We experience their love of the land as a way of life, a life that will endure only if our society can muster the economic means to support small business owners in this most essential undertaking of feeding a country.

The artistry of Ficara's lens and his genius at portraiture are exceptional. With this book his contribution to photography as both an art form and a documentary medium is secure. But no less remarkable is his choice of subject matter: working the land is an archetypal image of humanity, the idealized pastoral life having captured the

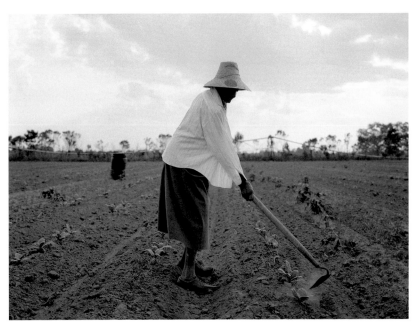

ROSA MURPHY HOEING. BROOKS COUNTY, GEORGIA

imagination of painters and poets for centuries. In the story of African American farming there is much bitterness and betrayal, but in these photographs that pastoral idealism is not entirely stripped away. We see evidence of America's ongoing struggle with race; with the economic differences between white and black America. These images offer silent testimony to the sorrow and sense of loss at the heart of black America's cry for fairness.

These pictures are timeless and speak to the best virtues of the American heart.

Here is a golden twilight to treasure—the story of black American farmers.

# Photographer's Note   JOHN FICARA

I began the black American farmers project in 1999 and, with the exception of several trips through the South in 2002, largely completed my work in 2001. For these four years I traveled around the country—in between my assignment work for a variety of American and European magazines—photographing roughly sixty farm owners from Alabama, Georgia, Louisiana, Michigan, Mississippi, North Carolina, and South Carolina. Time and again, county after county, in every state, farmers described a similar struggle of keeping their fields sufficiently productive to provide enough income to hold onto the land that has been in their families for generations. I soon discovered a common thread: a legacy of racial prejudice that black farmers continue to experience today—all of it documented in legal affidavits and actions against the United States Department of Agriculture.

For many of those I met, farming provides a means of existence that is at the heart of a lifestyle filled with family and church. During peak seasons they tirelessly commit to backbreaking work from sunrise to sunset. They sweat and pray for what most of us take for granted—a reasonable income and independence.

Daily, I was moved by the dignity, grace, humor, and spirit of the men and women I met. People such as Cleveland Jackson, who perseveringly patched the inner tube of his tractor tire nine times to save dollars needed elsewhere; Carl Whitehead, whose carefully tended cotton fields were planted past the optimum window because his operational loan from the government was delayed; and Roy Rolle, who has consistently refused developers' offers to buy the land that has been in his family for more than a century, even though it is now surrounded by suburban tract homes. The stories that these and other farmers tell are all laced with the dimming hope that each new season brings.

It is love of the land—land their parents and grandparents plowed and seeded—that compels the farmers I met to press on despite the inescapable bureaucratic challenges posed by the USDA and its local offices, which frequently fail to meet their responsibility of assisting black farmers. Because many of the farmers' children have been witness to the devastating hardship and, often, the foreclosure of farms owned by their parents, grandparents, friends, and neighbors, they have opted to leave behind farming and its way of life.

This story of America's black farmers is a quiet one that doesn't compete with the headlines of today. Nevertheless, it presents an important segment of our nation's history that is rapidly disappearing: many of the people on these pages will be the last to farm land that has been theirs for generations. These photographs will not change the course of their history; however, I hope the images will document for years to come the lives of certain last-generation black farmers in America.

"I believe the man upstairs
looked over this farm
and my family."

**GRIFFEN TODD** WAKE COUNTY, NORTH CAROLINA

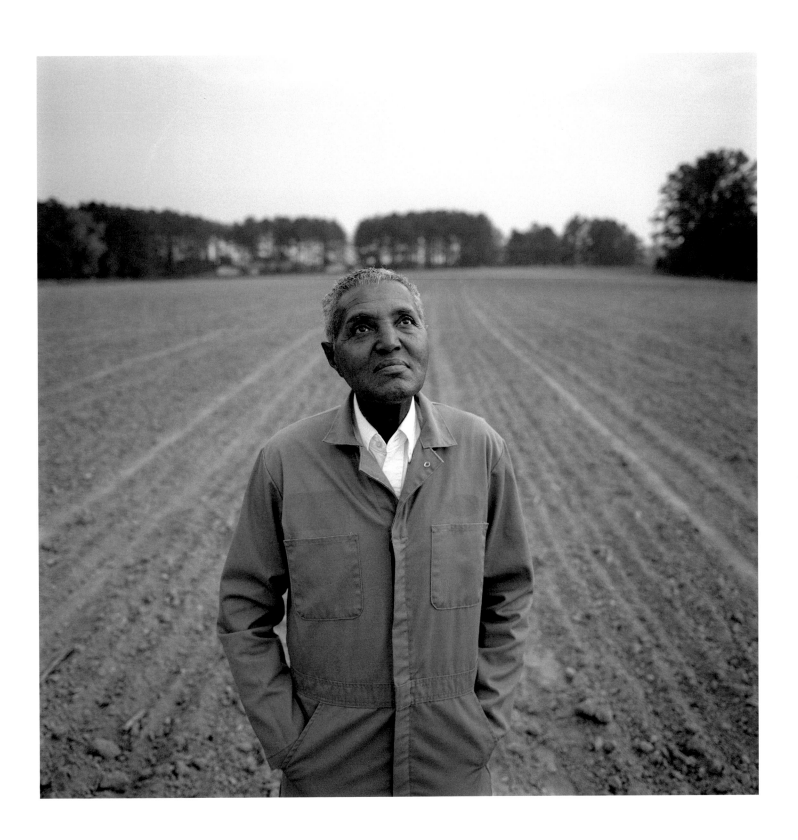

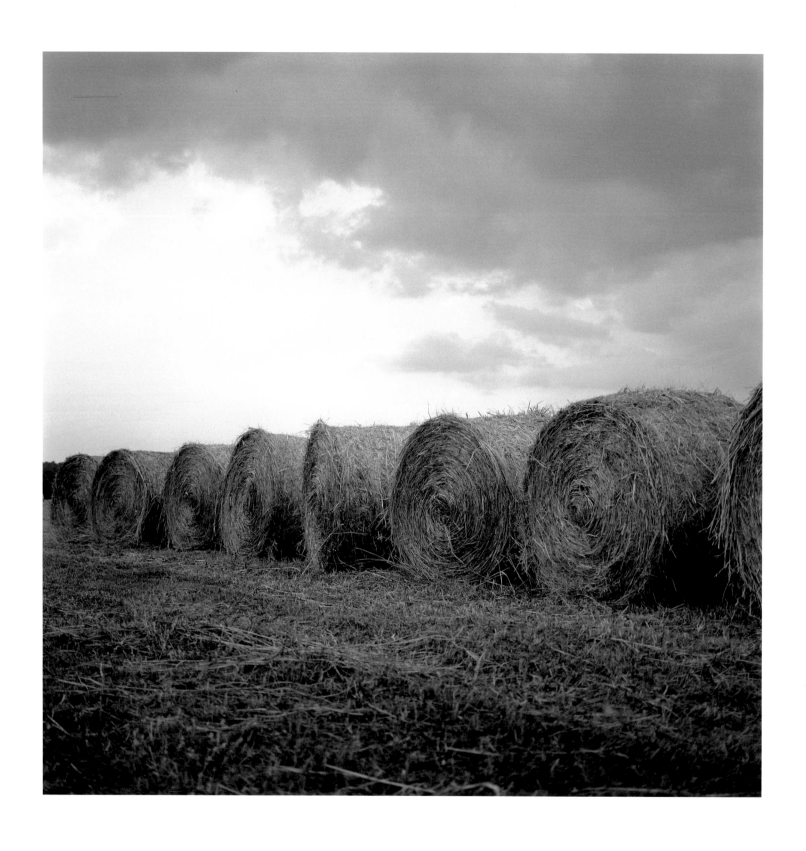

Hay rolls  GREENE COUNTY, ALABAMA

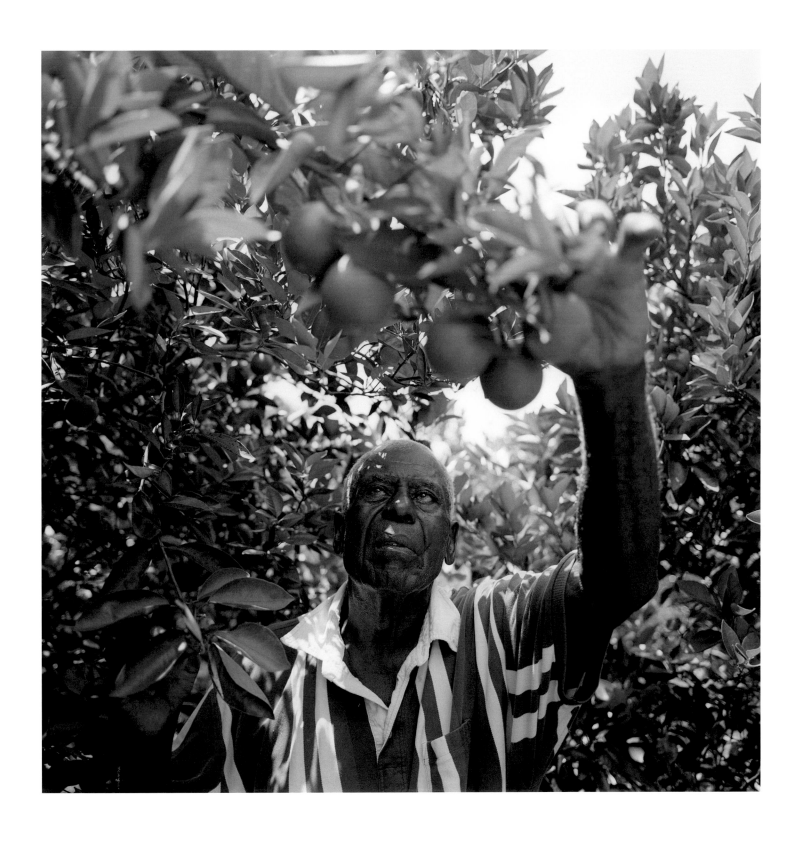

George Jackson  LAKE COUNTY, FLORIDA

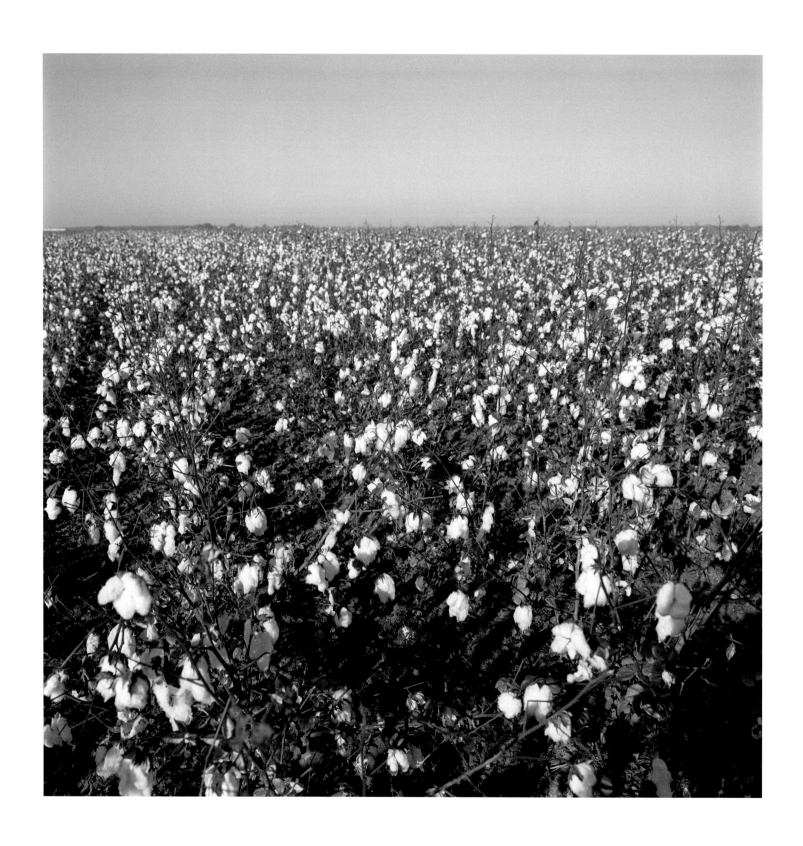

Cotton field   HUMPHREYS COUNTY, MISSISSIPPI

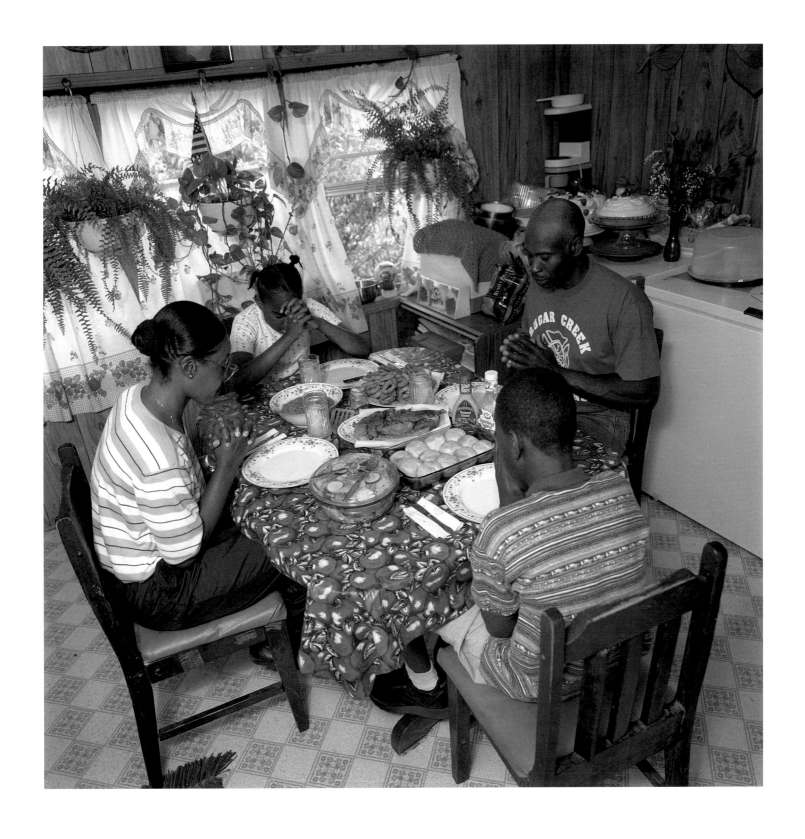

Belinda, Jonathan, Roger, and Kendra Lamar   PUTNAM COUNTY, GEORGIA

*Overleaf:* Preparing the field   DOOLY COUNTY, GEORGIA

5

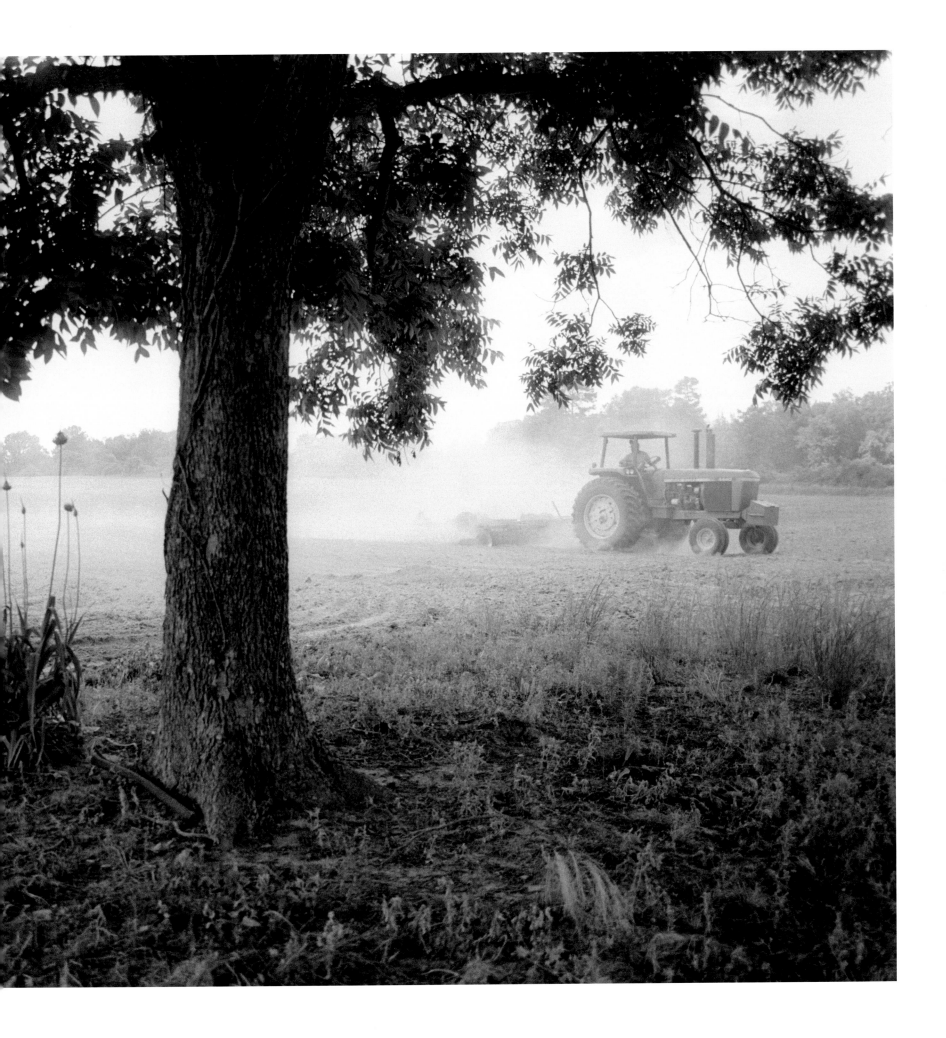

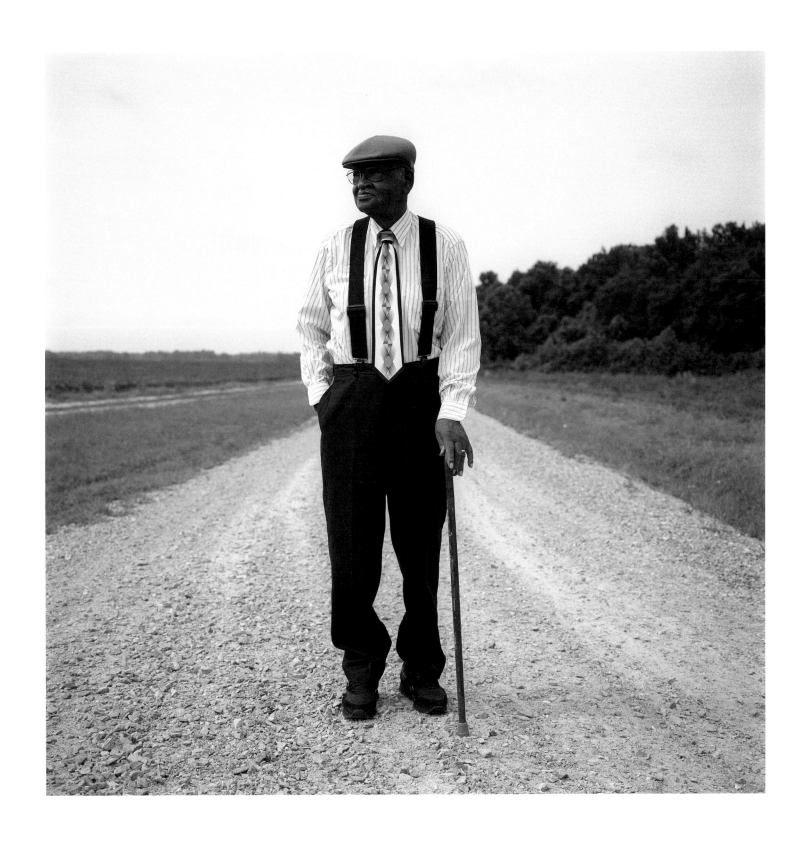

Matthew Grant   HALIFAX COUNTY, NORTH CAROLINA

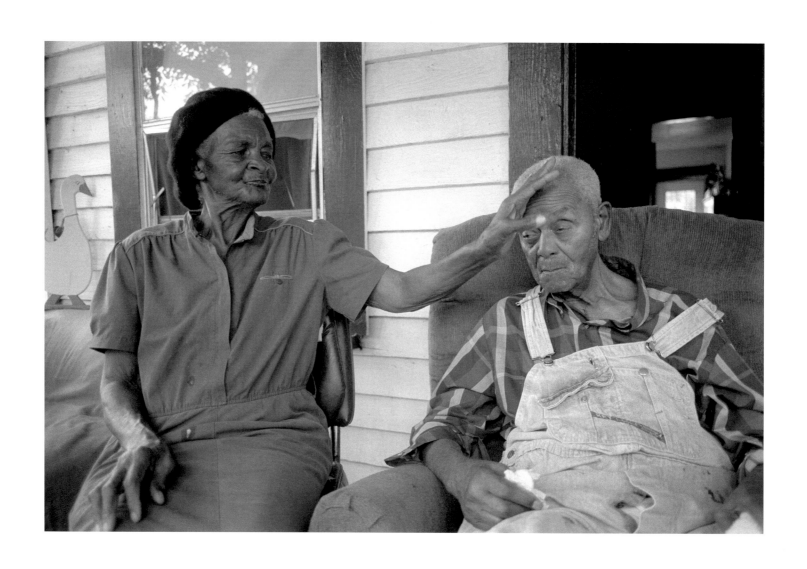

Rosa and Eddie Murphy  BROOKS COUNTY, GEORGIA

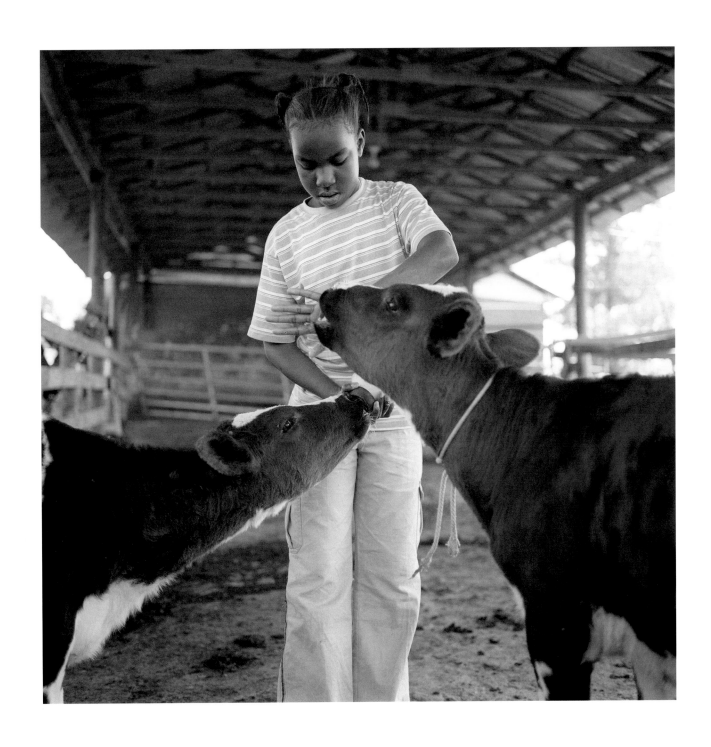

Kendra Lamar  PUTNAM COUNTY, GEORGIA

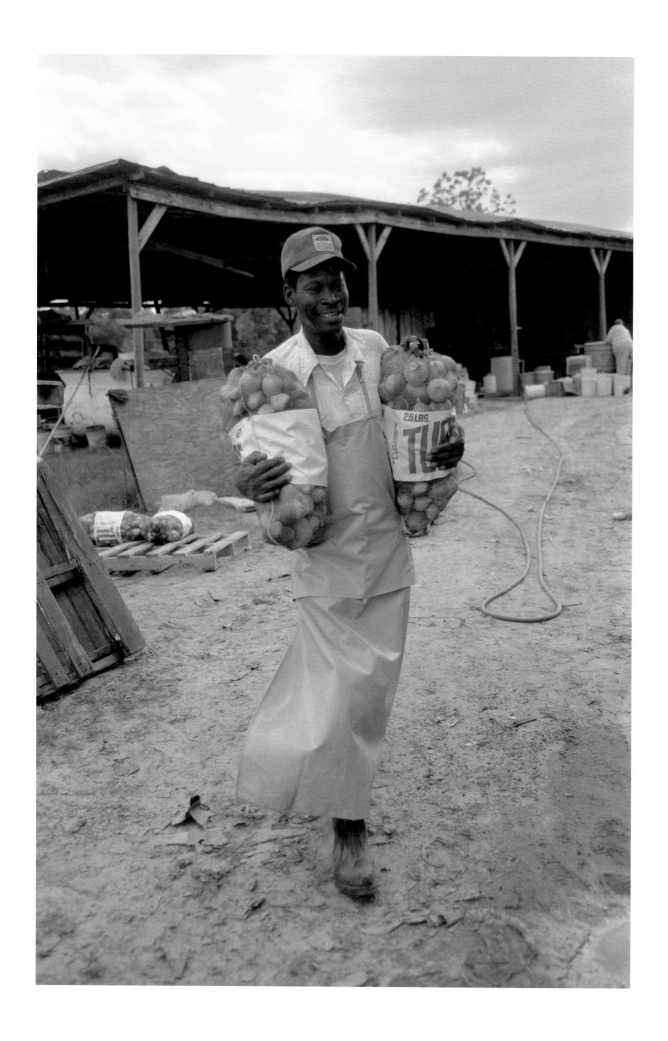

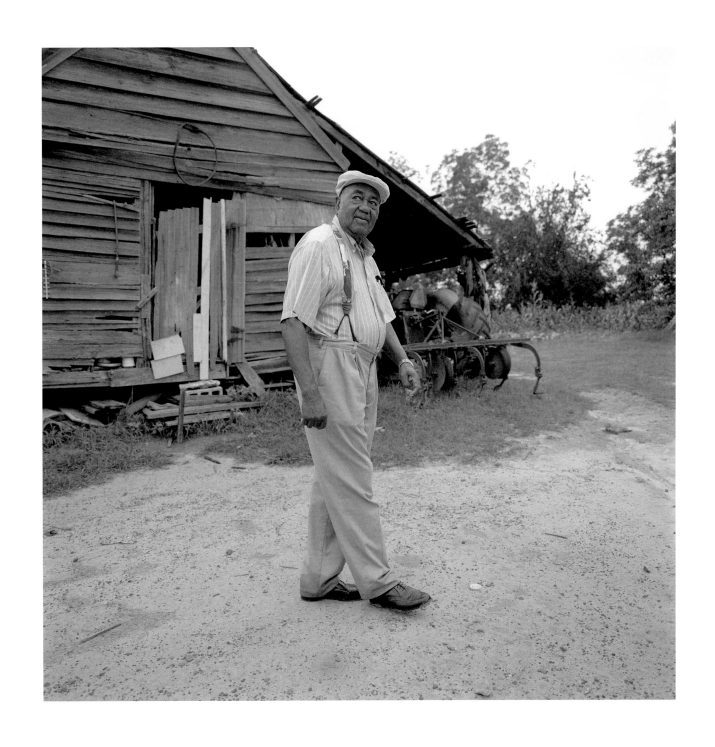

Carranza Morgan Sr.   SUMTER COUNTY, GEORGIA

*Left:* Elton "Li'l Bro" Williams   MARABLE FARM, THOMAS COUNTY, GEORGIA

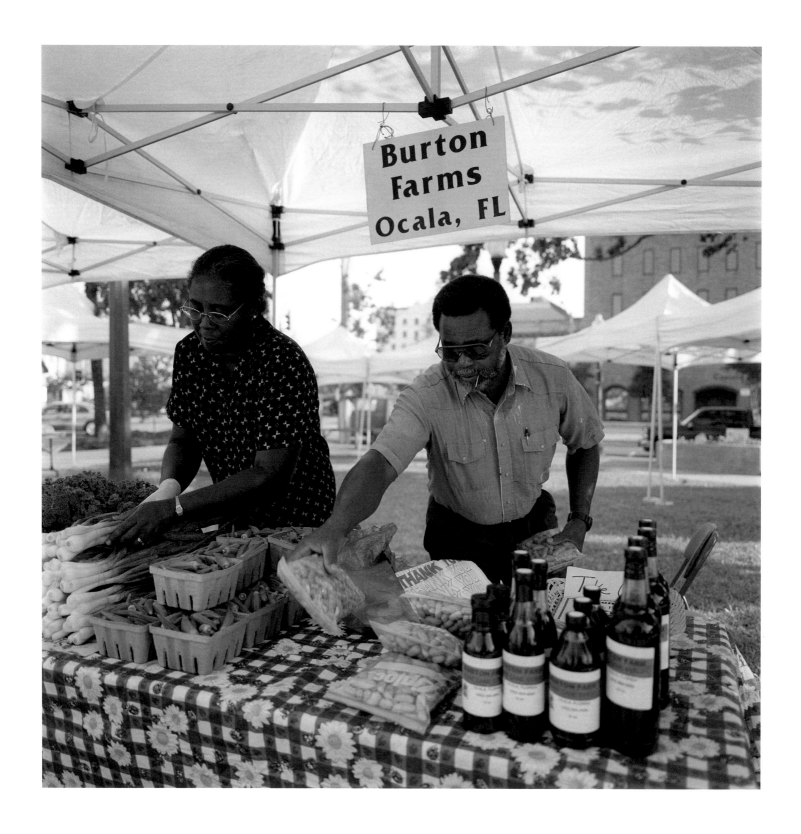

Alice and Ron Burton   MARION COUNTY, FLORIDA

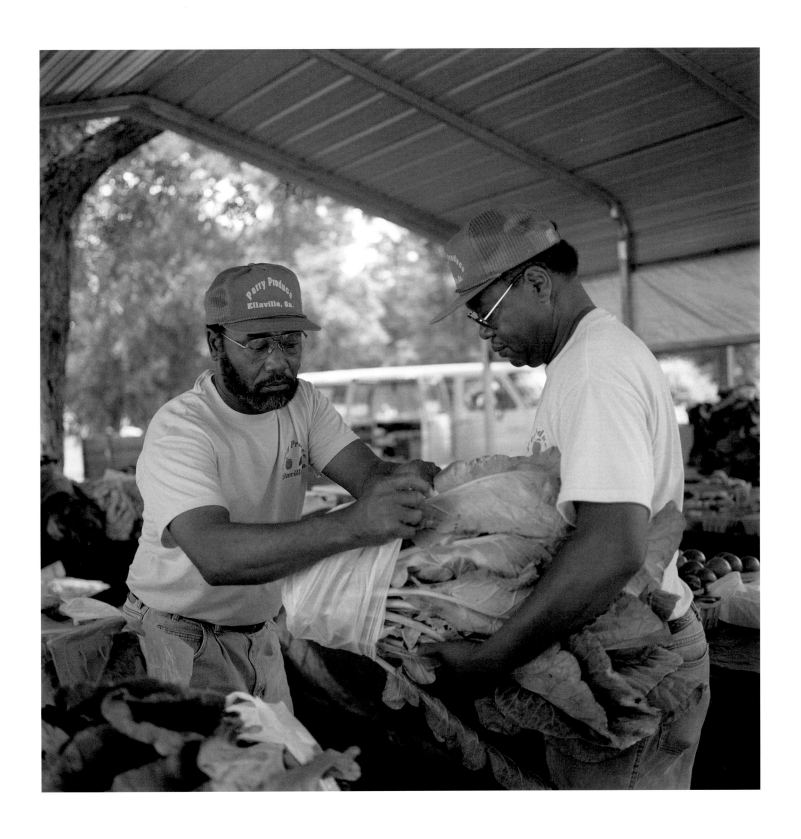

Fred and Phillip Perry   SCHLEY COUNTY, GEORGIA

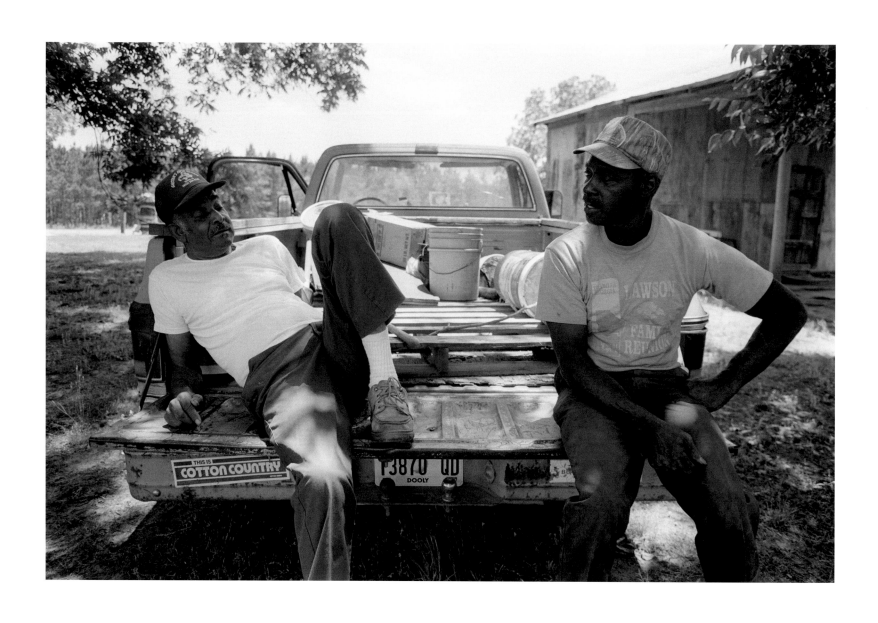

Hendley Bryant and William Lawson  DOOLY COUNTY, GEORGIA

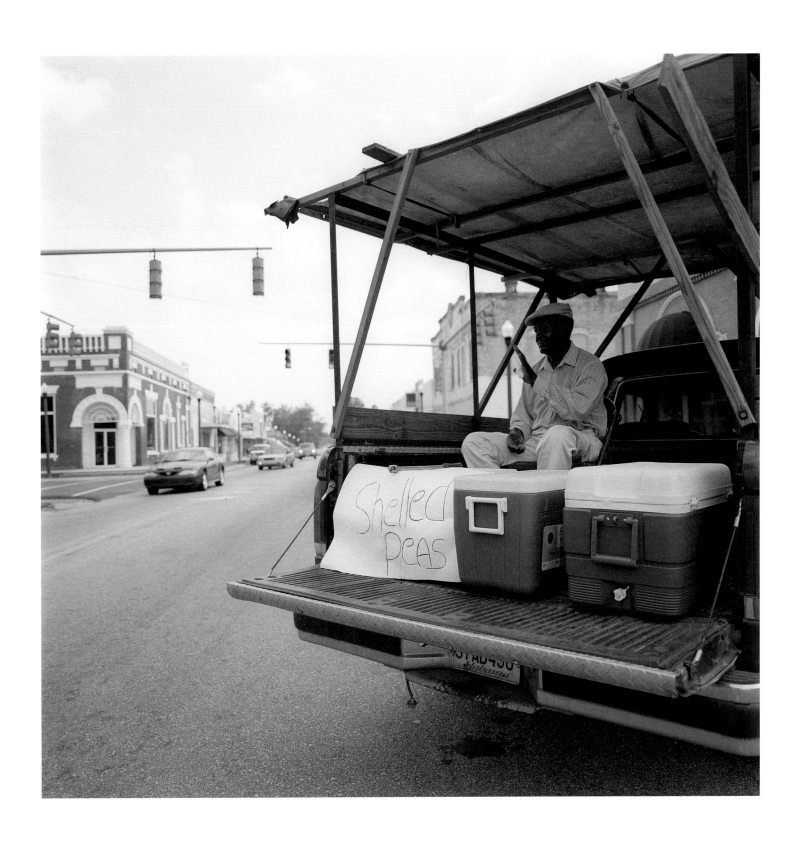

Ulyess Blackmon   HENRY COUNTY, ALABAMA

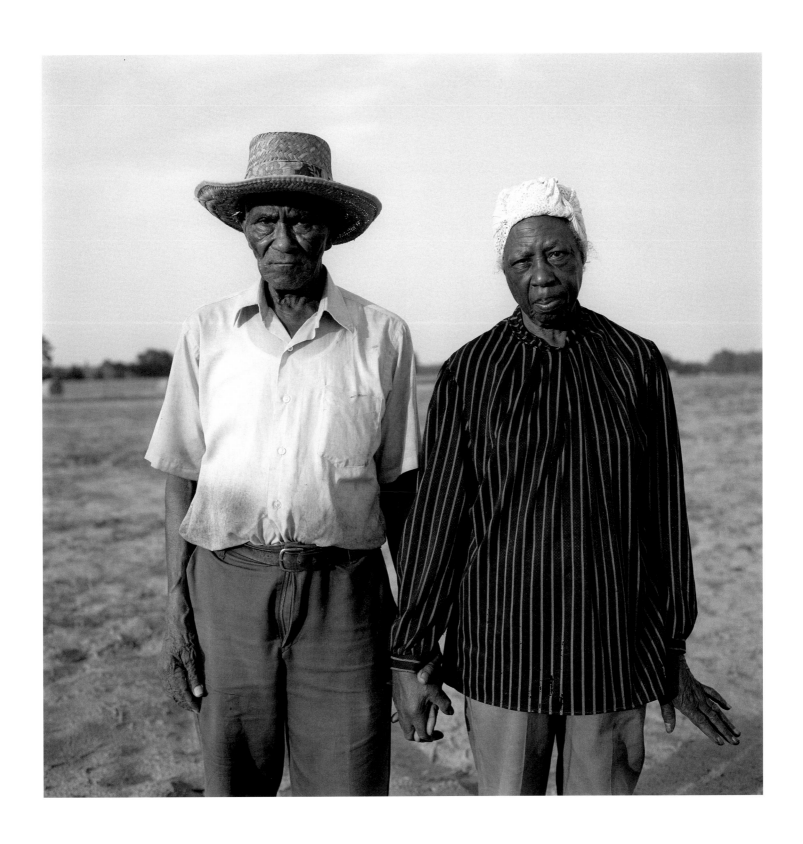

John and Evelena Burton   MARION COUNTY, FLORIDA

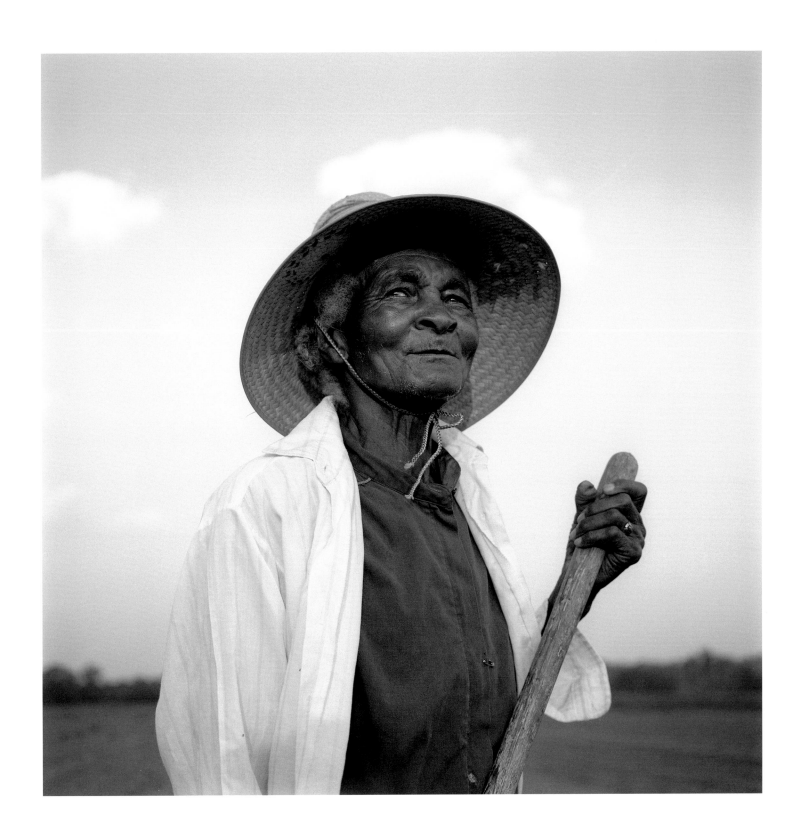

Rosa Murphy    BROOKS COUNTY, GEORGIA

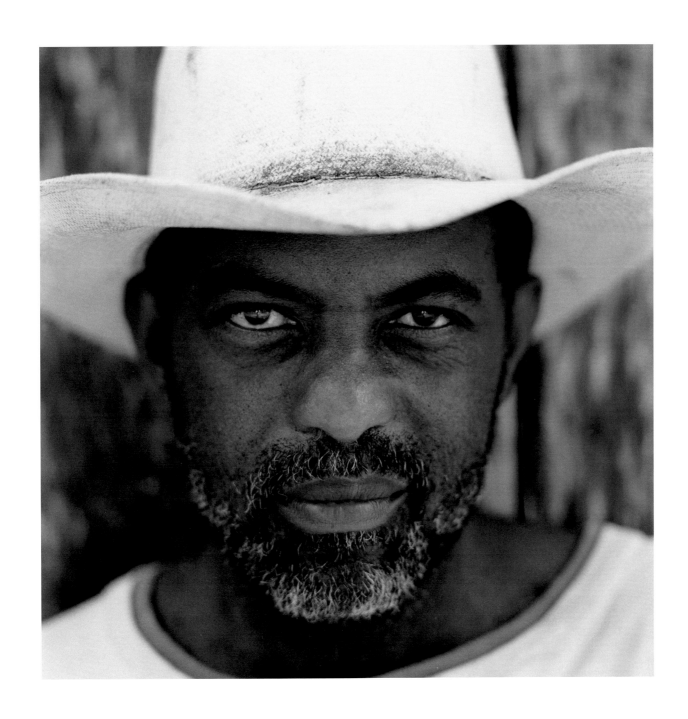

Eddie Cole   GREENE COUNTY, ALABAMA

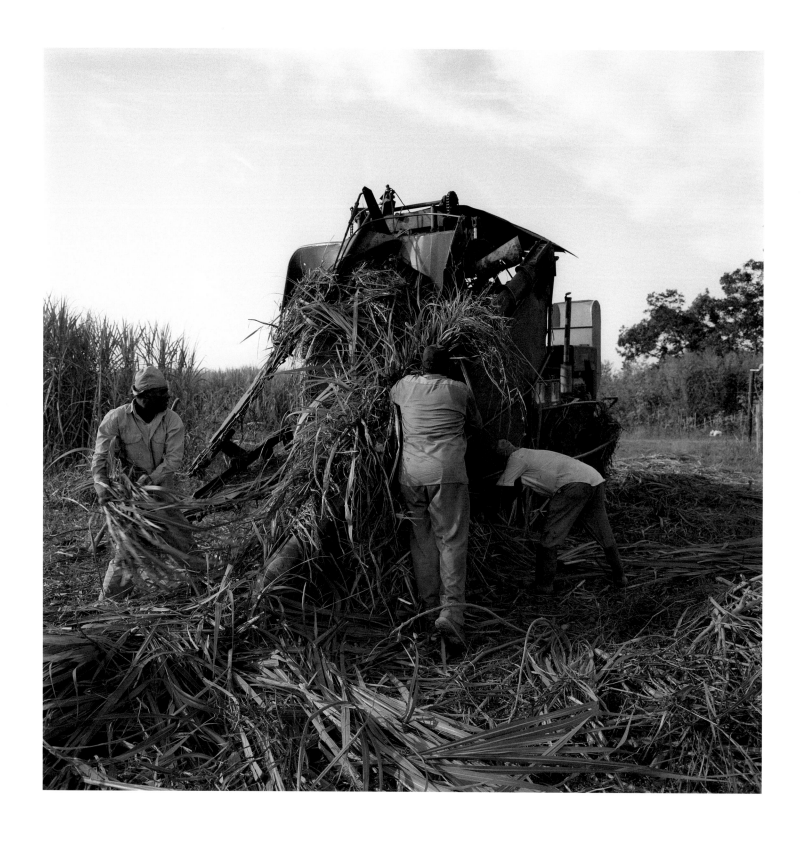

Sugarcane harvest   SAINT MARY PARISH, LOUISIANA

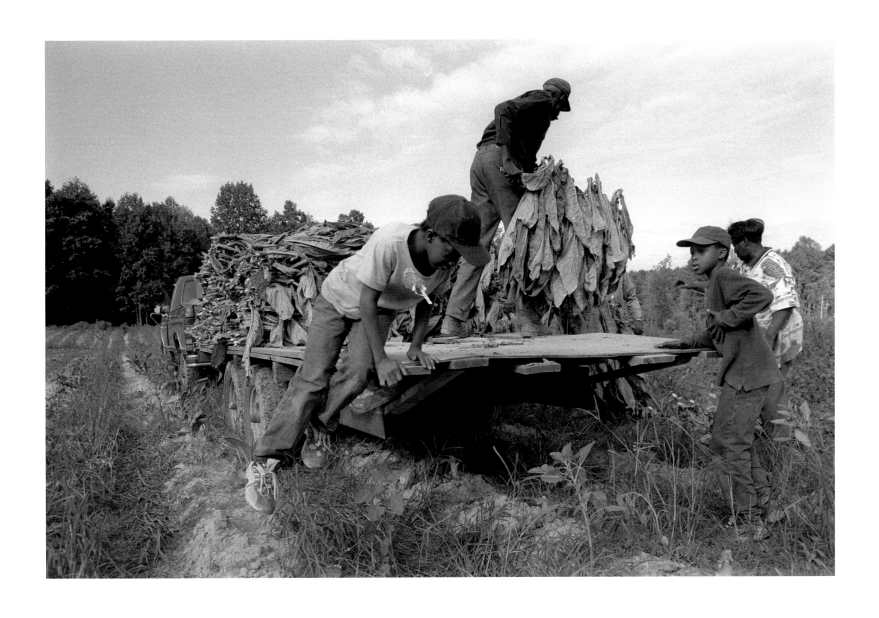

Tobacco harvest   BUCKINGHAM COUNTY, VIRGINIA

"We can't seem to benefit from increased prices at the top. Prices for produce bushels have pretty much remained the same."

**EDDIE COLE** GREENE COUNTY, ALABAMA

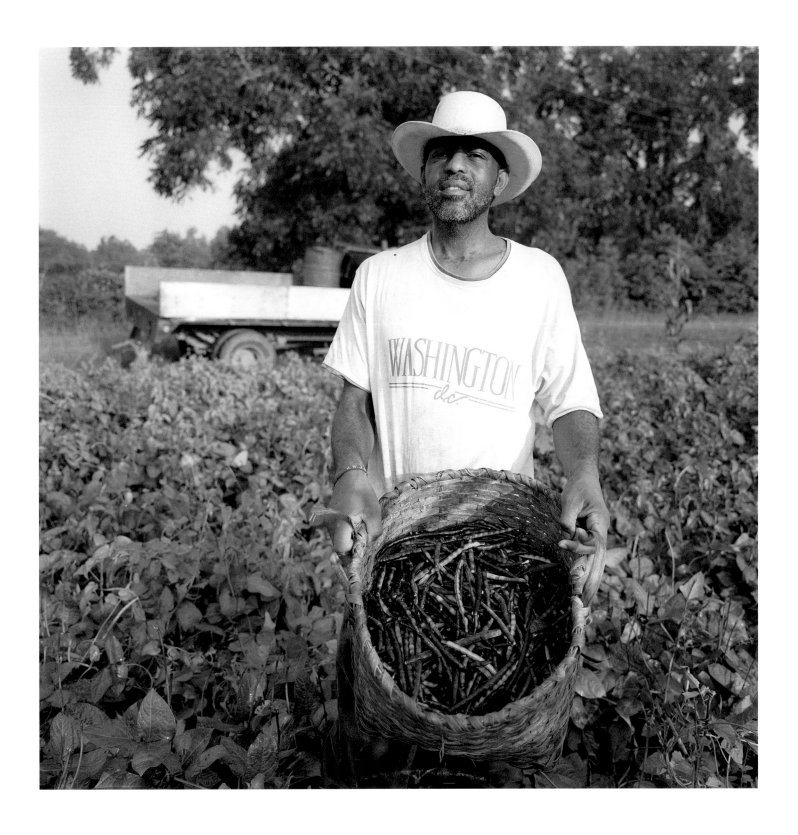

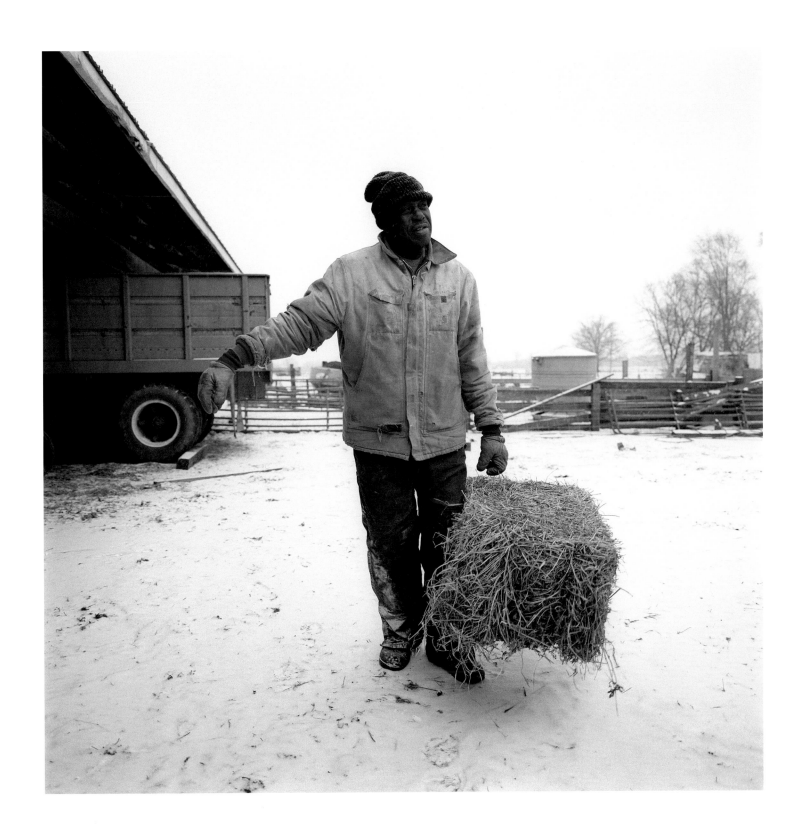

Mitchell Brambly   CASS COUNTY, MICHIGAN

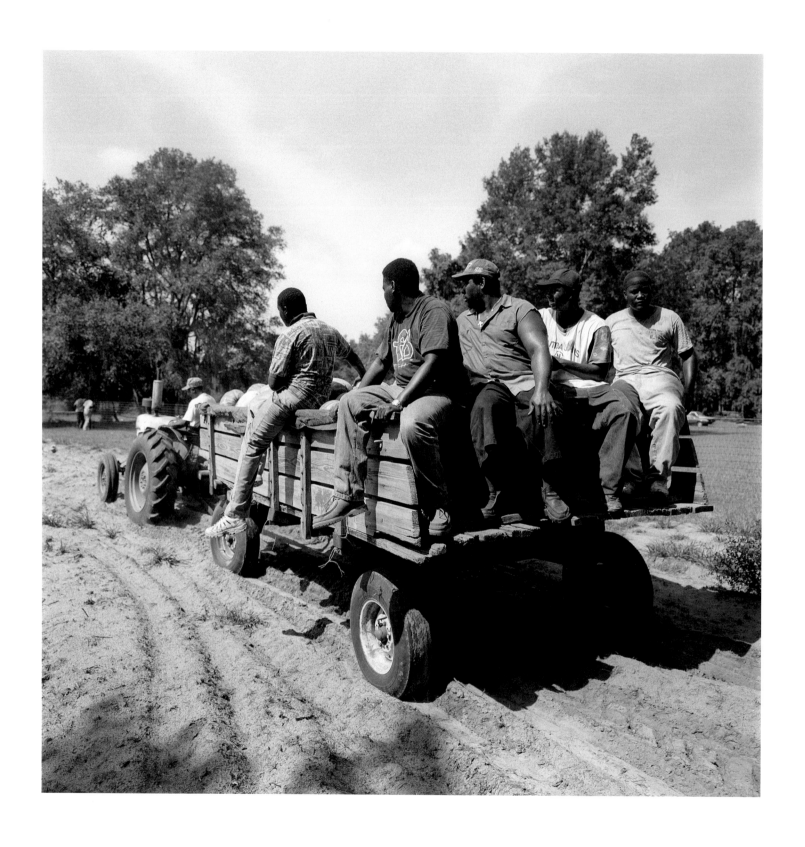

Virgil Pullins and local high school football players   MARION COUNTY, FLORIDA

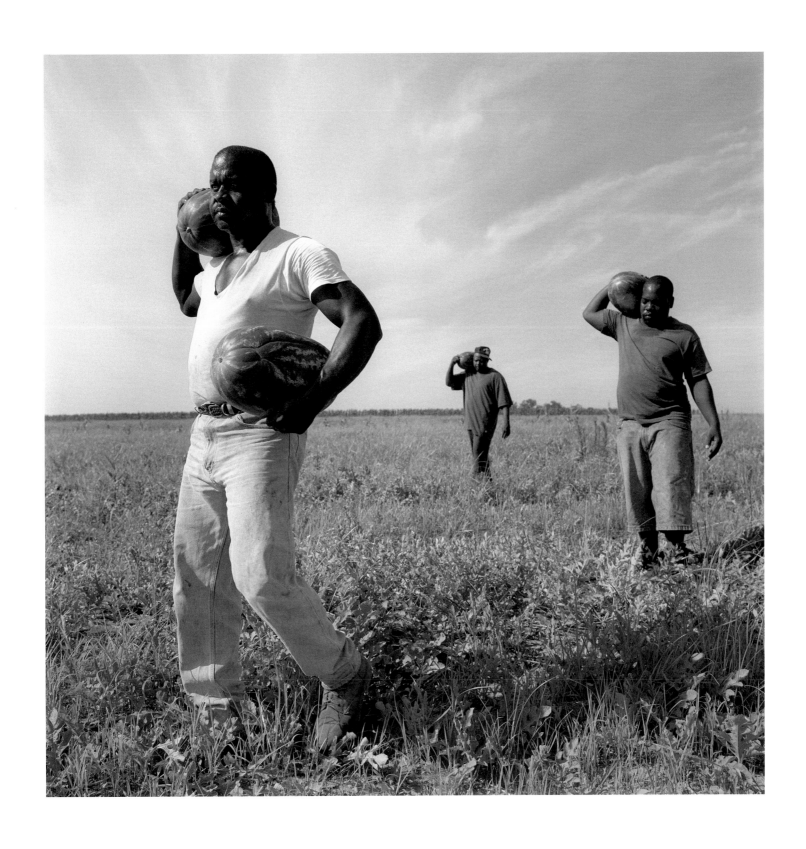

Willie Head and neighbors   THOMAS COUNTY, GEORGIA

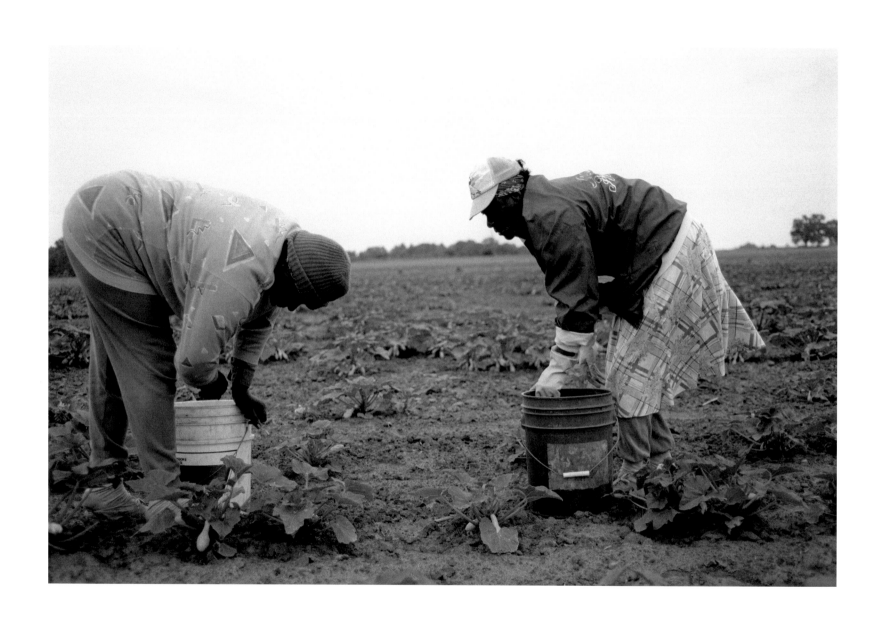

Produce harvest    MARABLE FARM, THOMAS COUNTY, GEORGIA

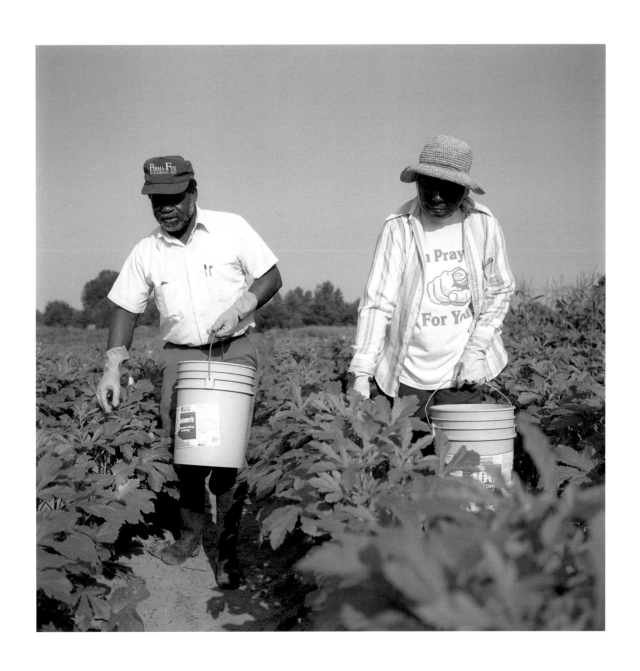

Ron and Alice Burton    MARION COUNTY, FLORIDA

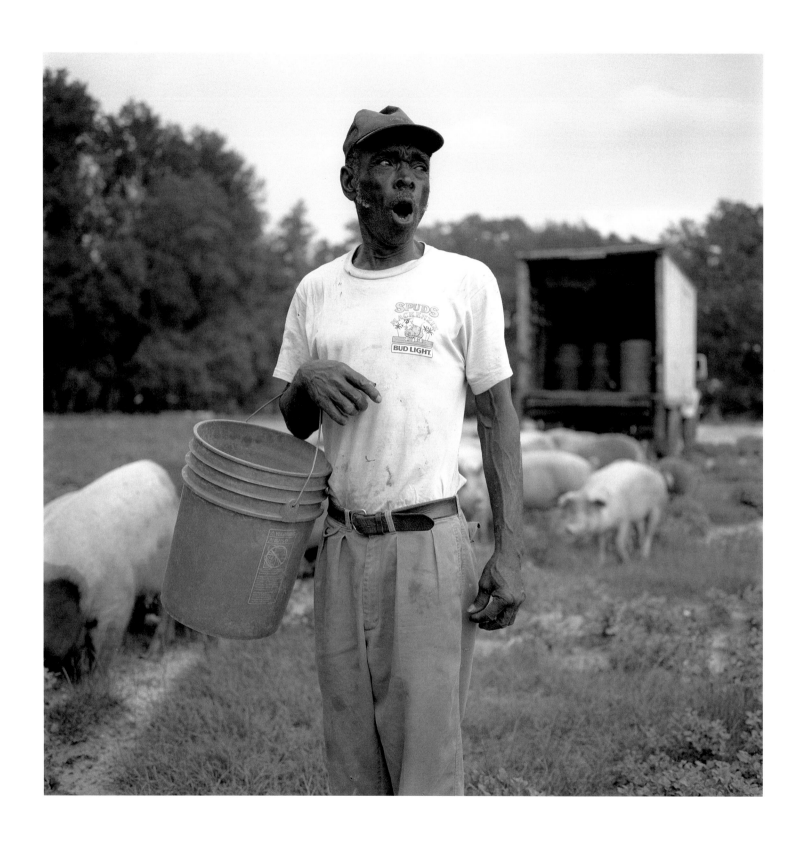

Joe Haynes Jr. MARION COUNTY, FLORIDA

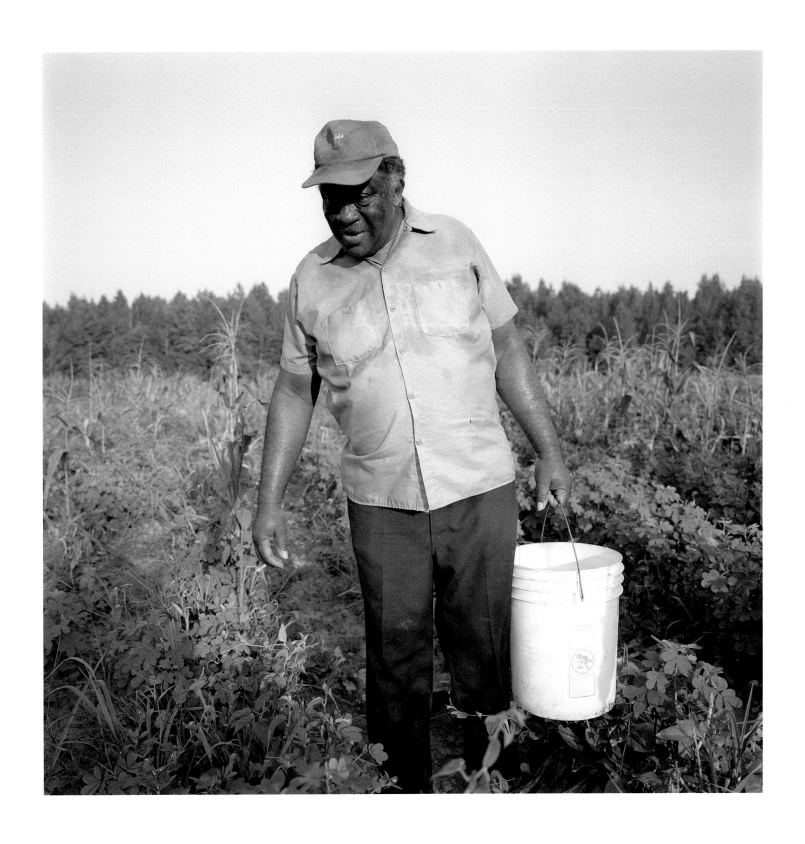

Charles Williams   SUMTER COUNTY, ALABAMA

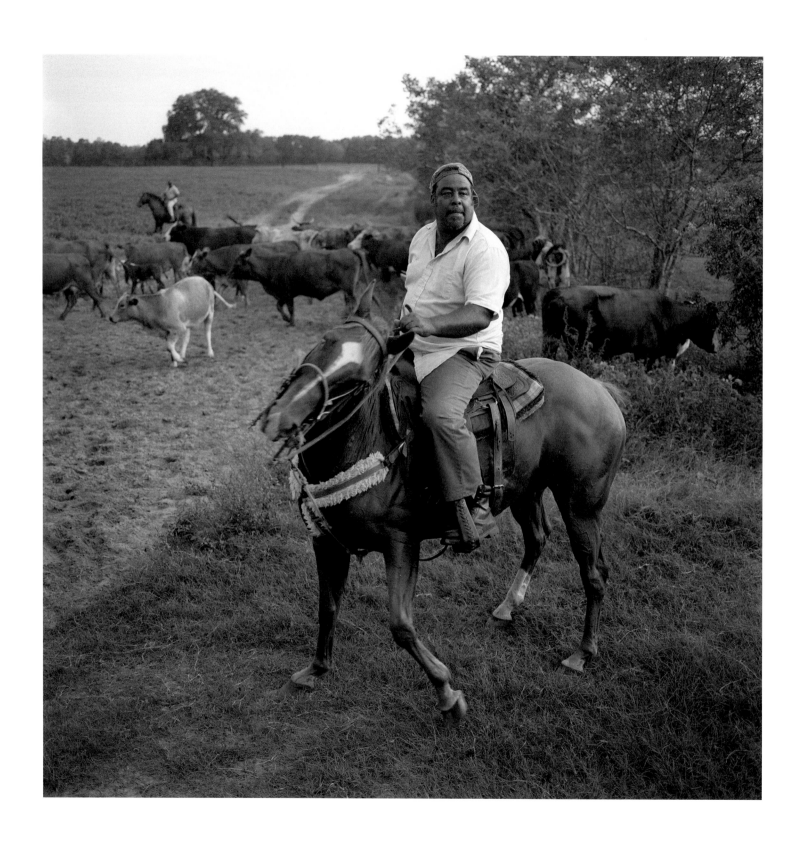

Homer Gary   MARION COUNTY, FLORIDA

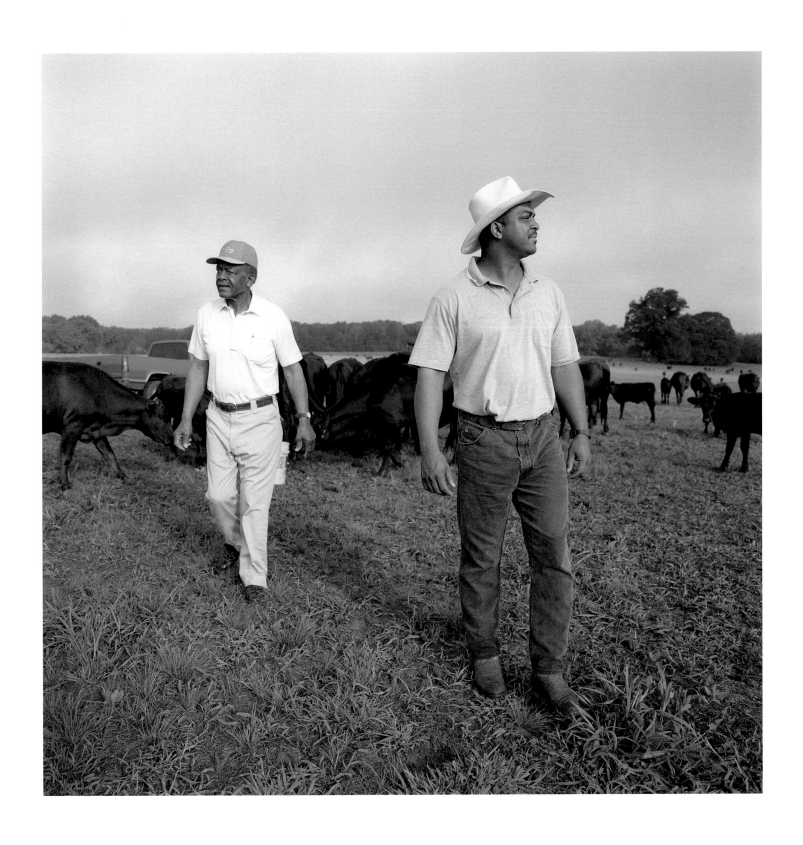

Harry and Donald Means   GREENE COUNTY, ALABAMA

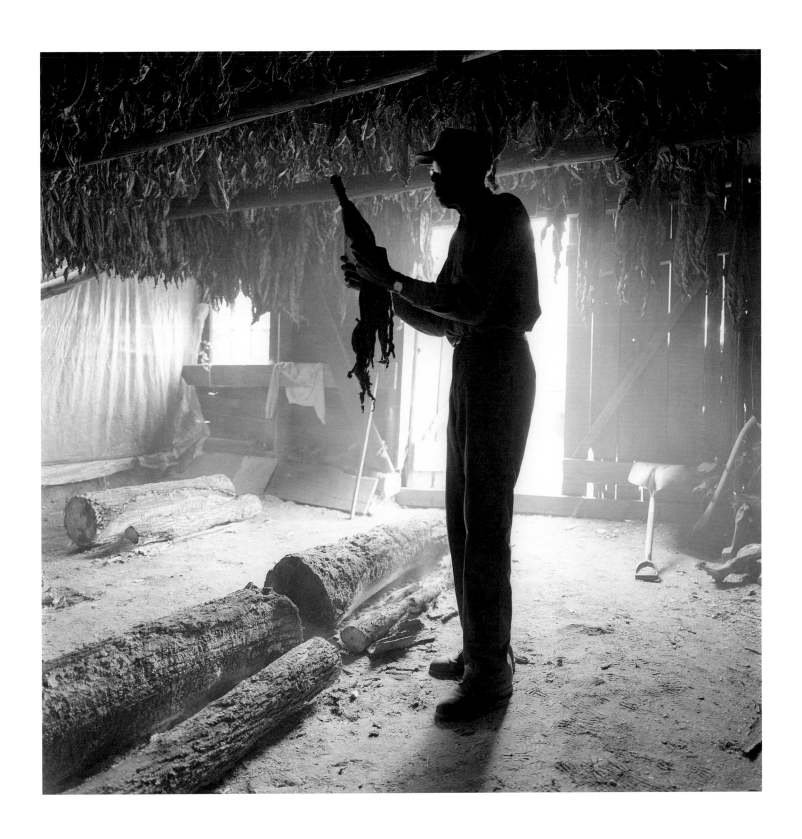

Hoover Johnson   BUCKINGHAM COUNTY, VIRGINIA

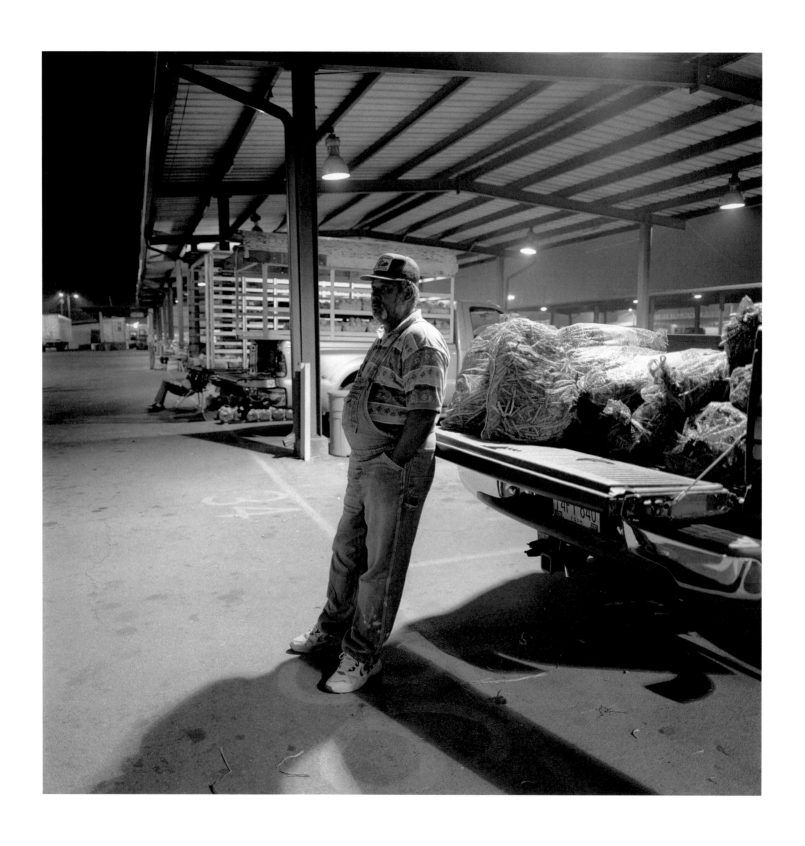

Jessie Caver   CHILTON COUNTY, ALABAMA

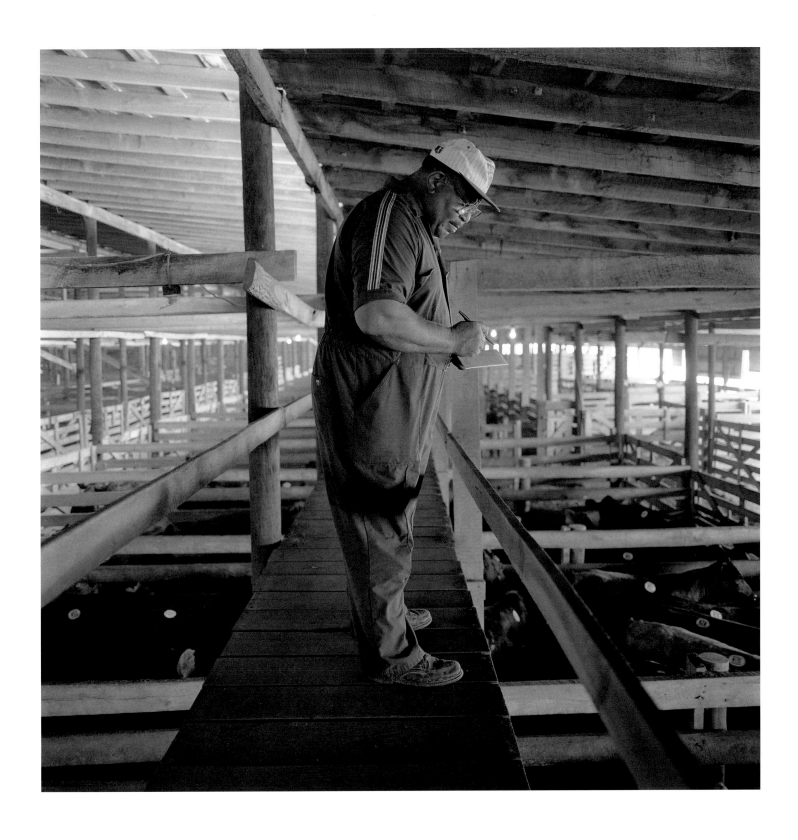

Levi Morrow  GREENE COUNTY, ALABAMA

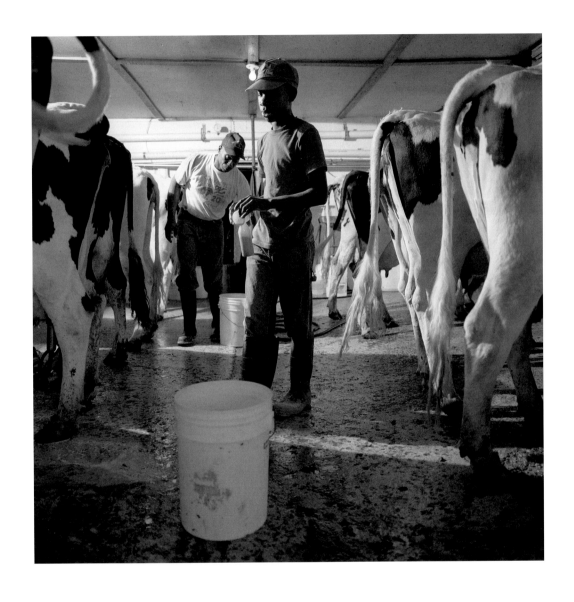

Roger and Jonathan Lamar   PUTNAM COUNTY, GEORGIA

*Left:* Lamar family milking barn before dawn

"The difficulties have always
been in getting the monies
to run the farm."

**DIANE CAVER**  CHILTON COUNTY, ALABAMA

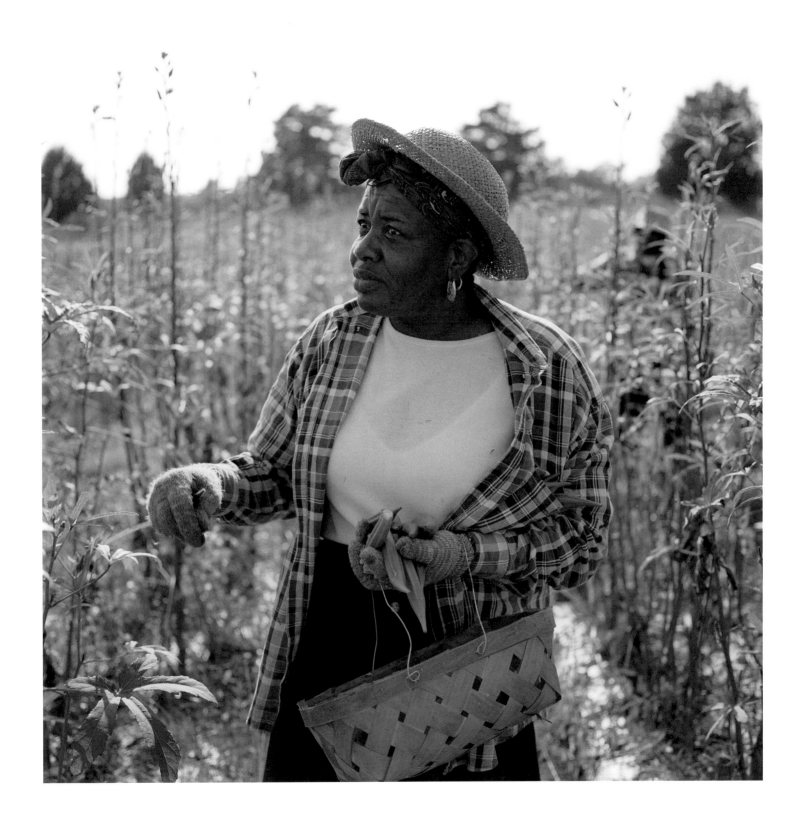

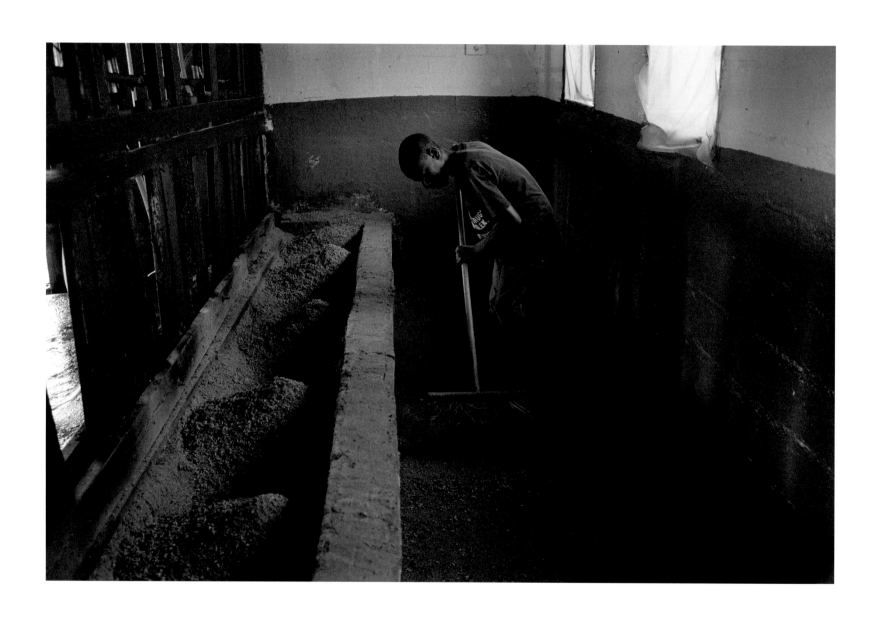

Jonathan Lamar   PUTNAM COUNTY, GEORGIA

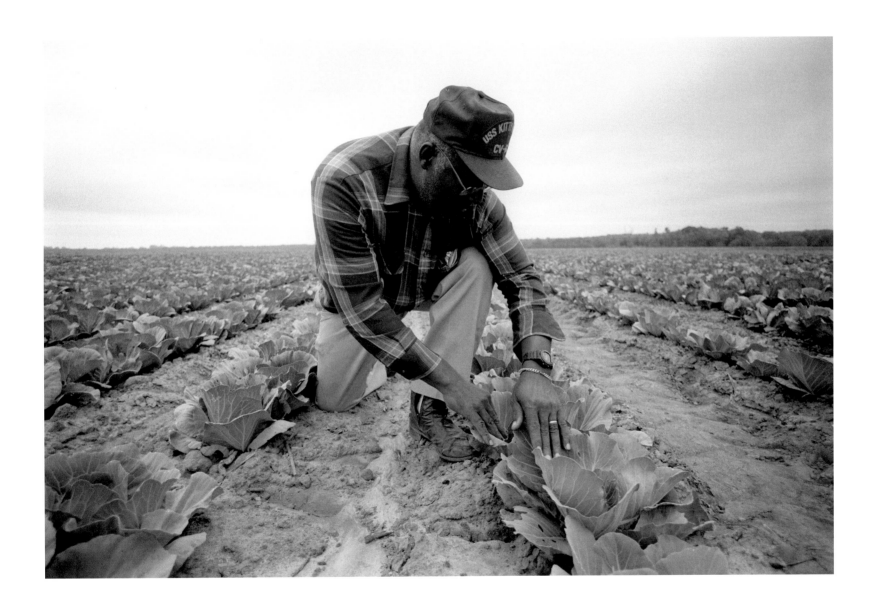

Luther Marable   MARABLE FARM, THOMAS COUNTY, GEORGIA
*Overleaf:* Blueberry pickers in the early morning   VAN BUREN COUNTY, MICHIGAN

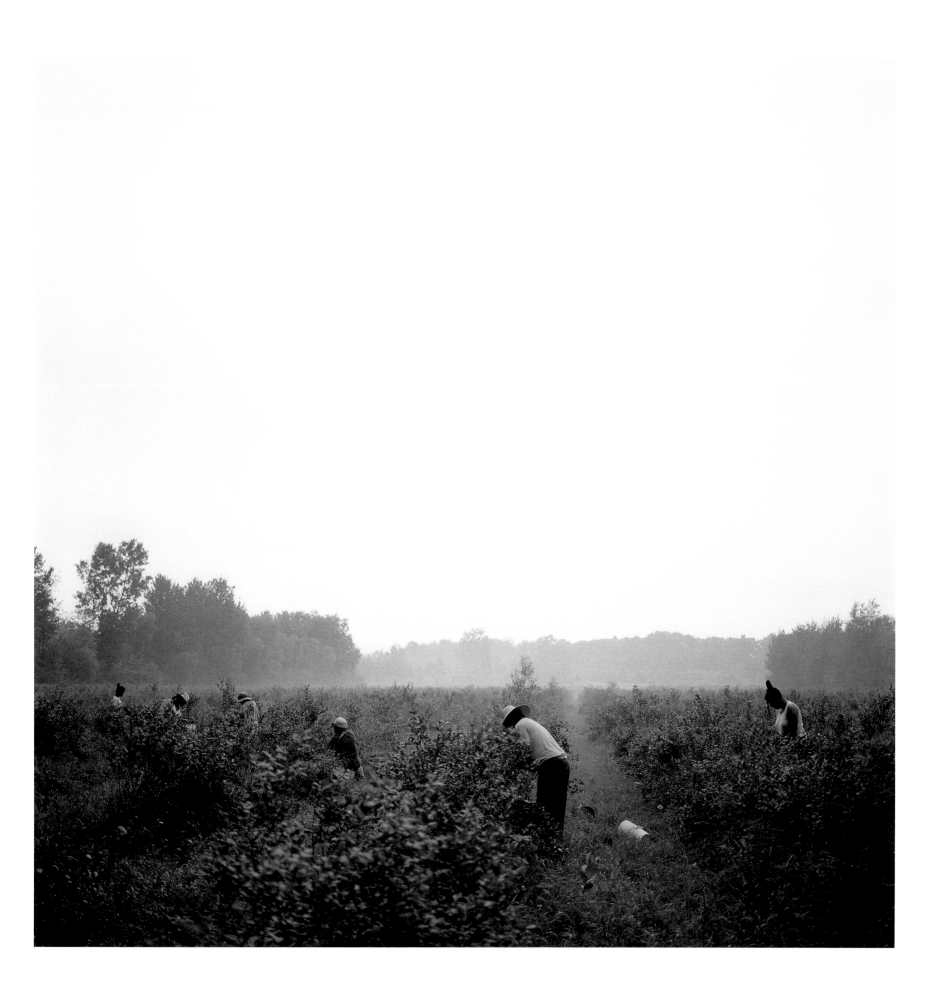

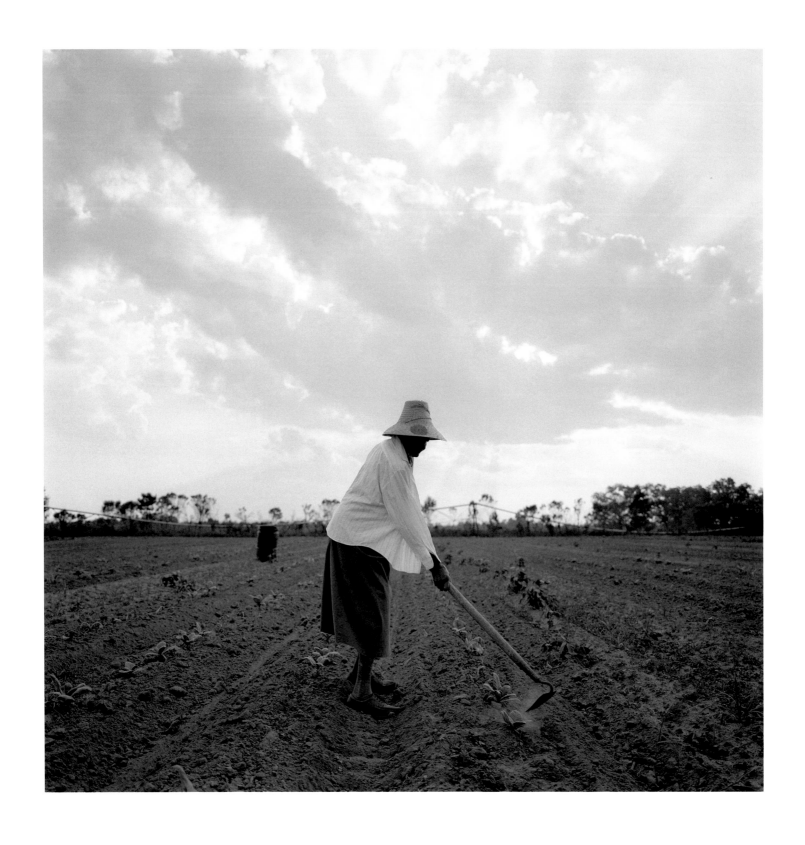

Rosa Murphy hoeing   BROOKS COUNTY, GEORGIA

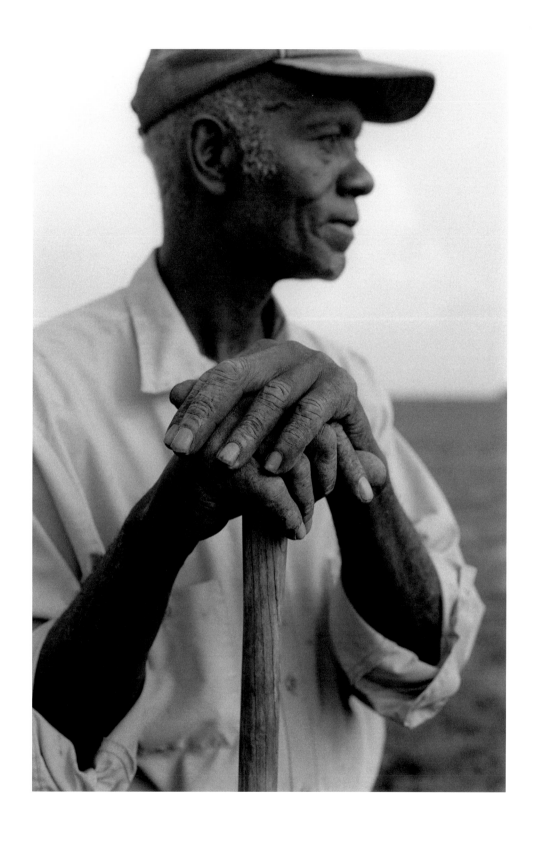

Freddie Samuel  MARABLE FARM, THOMAS COUNTY, GEORGIA

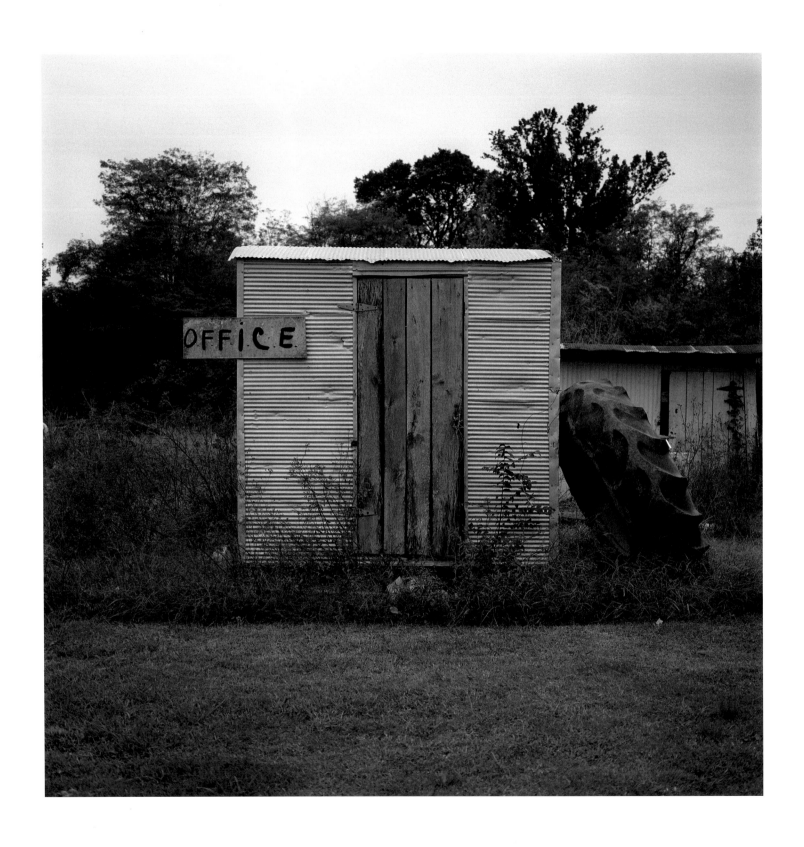

Toolshed   HOLMES COUNTY, MISSISSIPPI

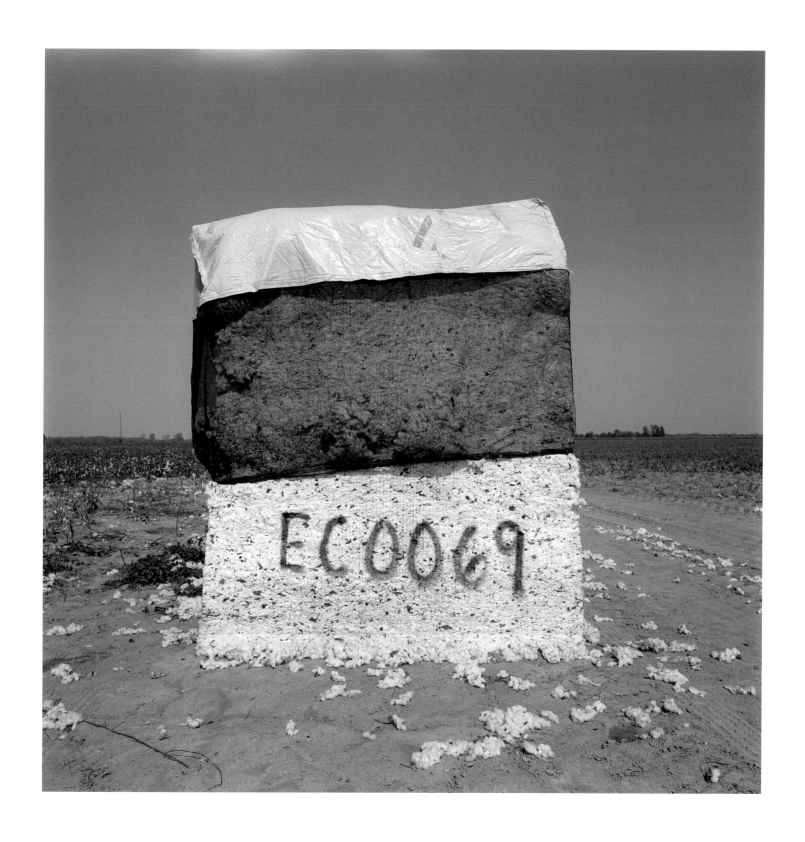

Cotton module   HUMPHREYS COUNTY, MISSISSIPPI

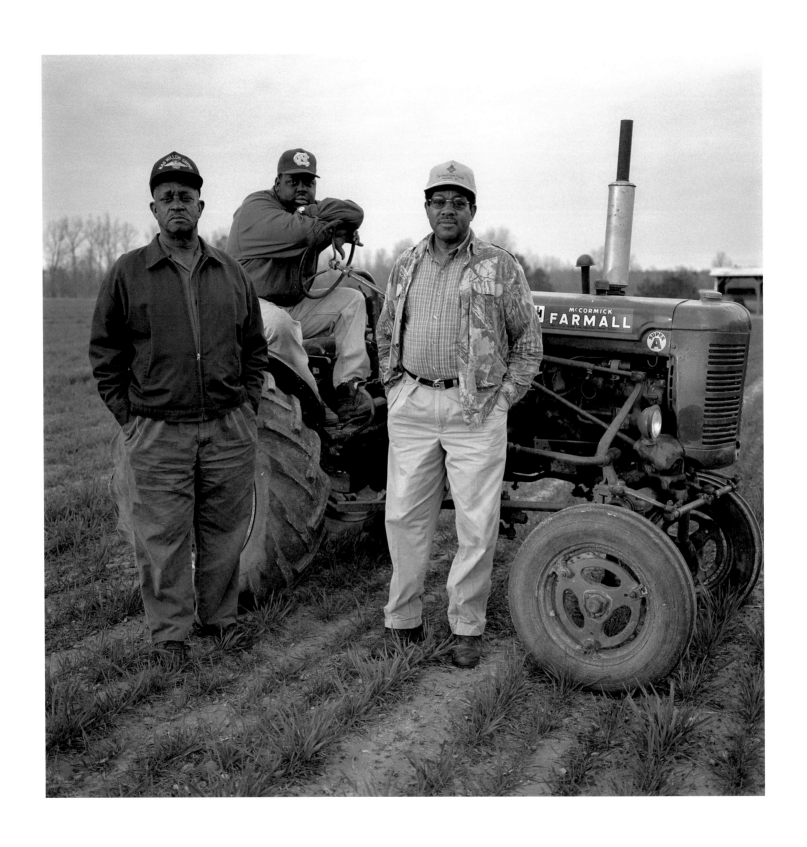

James Davis Sr., James Davis III, and James Davis Jr.  HALIFAX COUNTY, NORTH CAROLINA

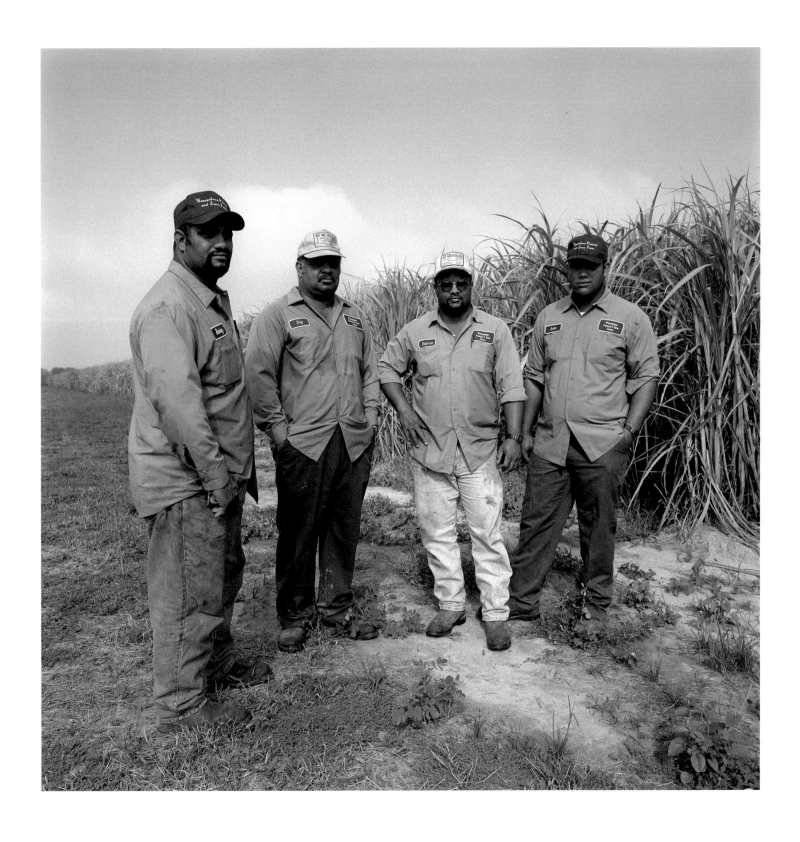

Rodney, Wenceslaus, Edward, and June Provost   IBERIA PARISH, LOUISIANA

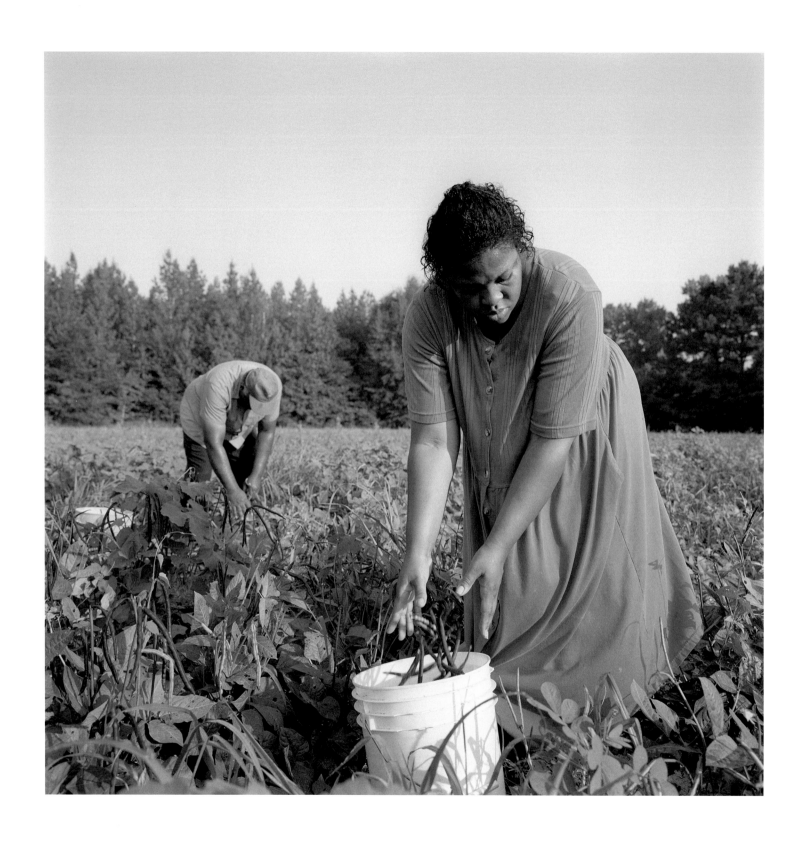

Charles and Anne Williams    SUMTER COUNTY, ALABAMA

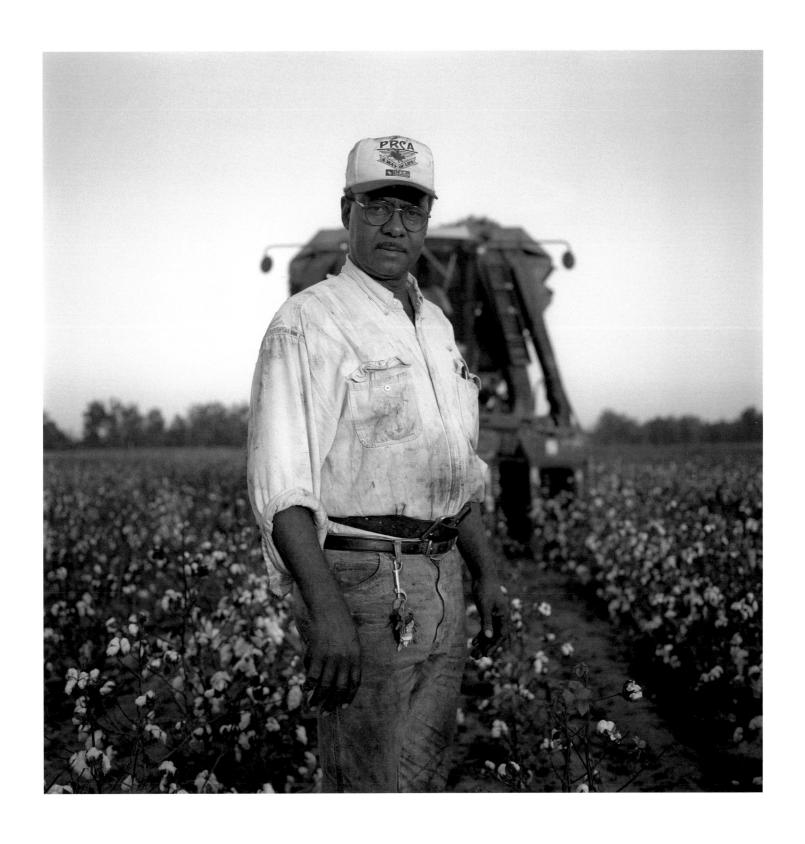

Edmond Clark    HUMPHREYS COUNTY, MISSISSIPPI

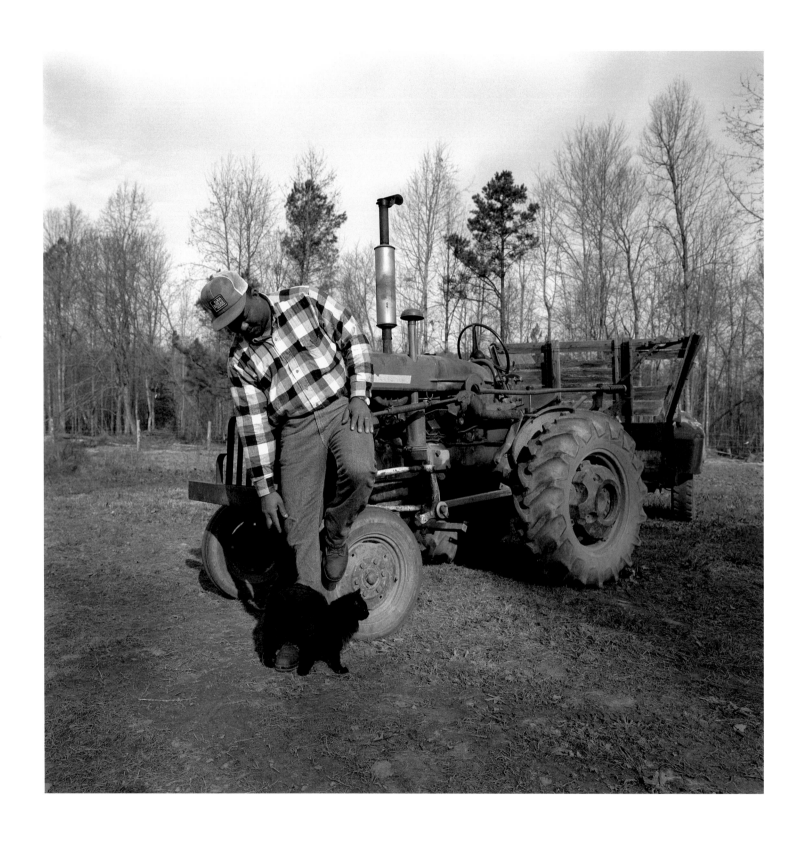

James Davis Jr. WARREN COUNTY, NORTH CAROLINA

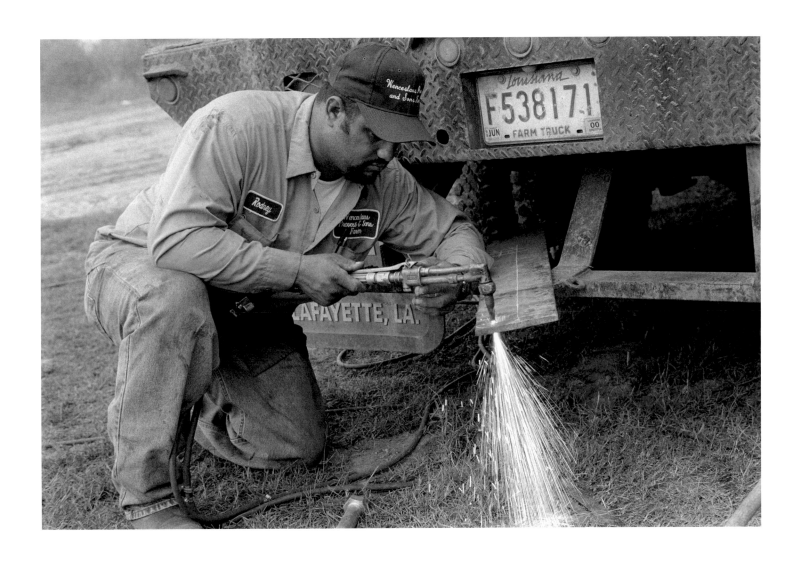

Rodney Provost   IBERIA PARISH, LOUISIANA

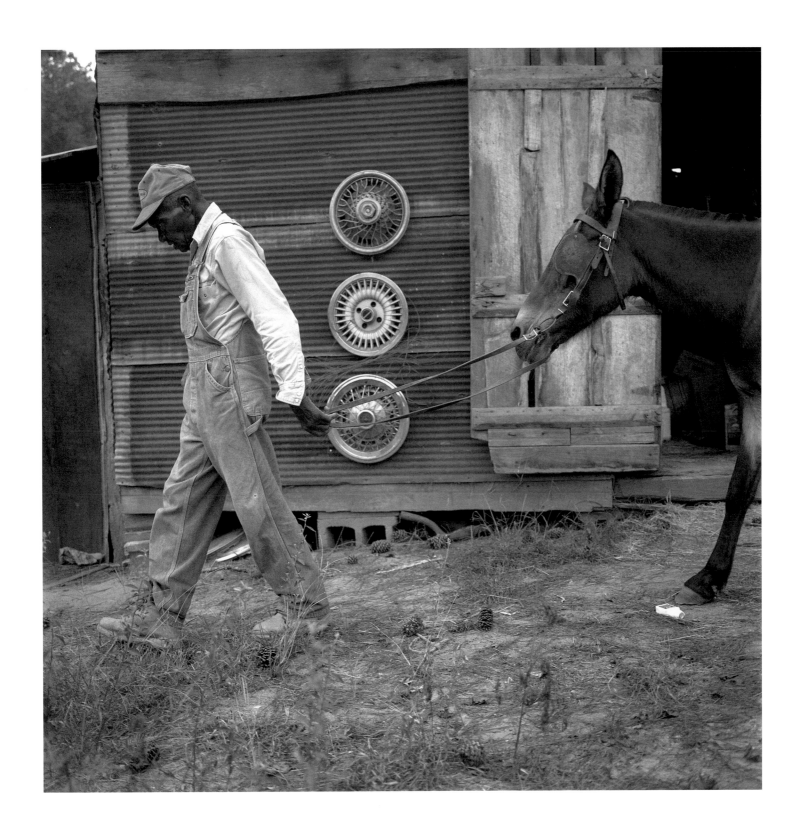

Jerry Singleton leading "Tat"  LEE COUNTY, ALABAMA

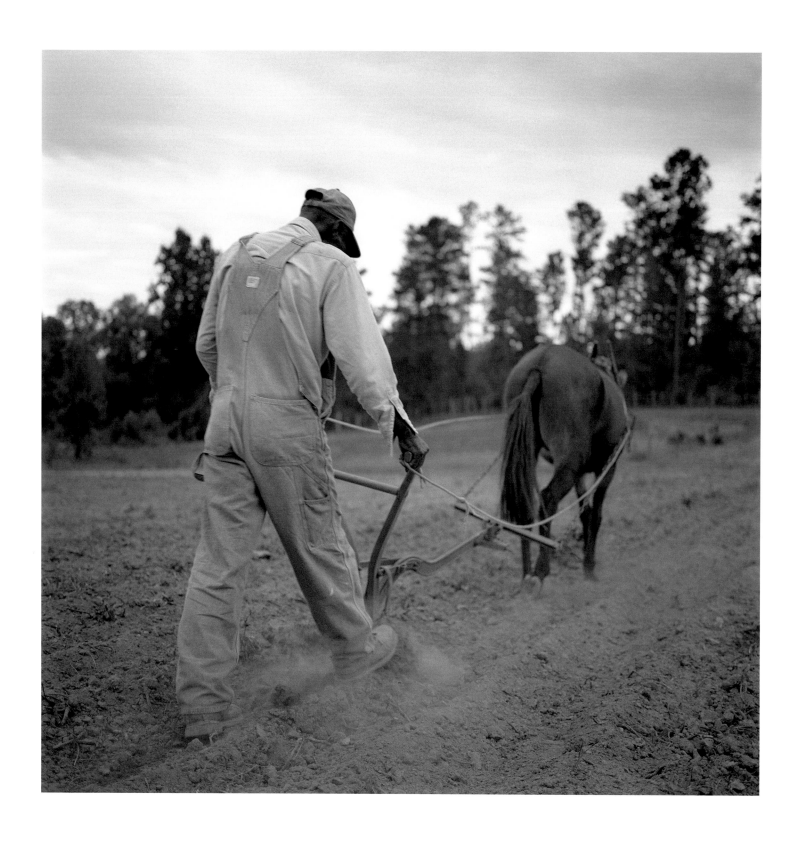

Jerry Singleton plowing with "Tat"   LEE COUNTY, ALABAMA

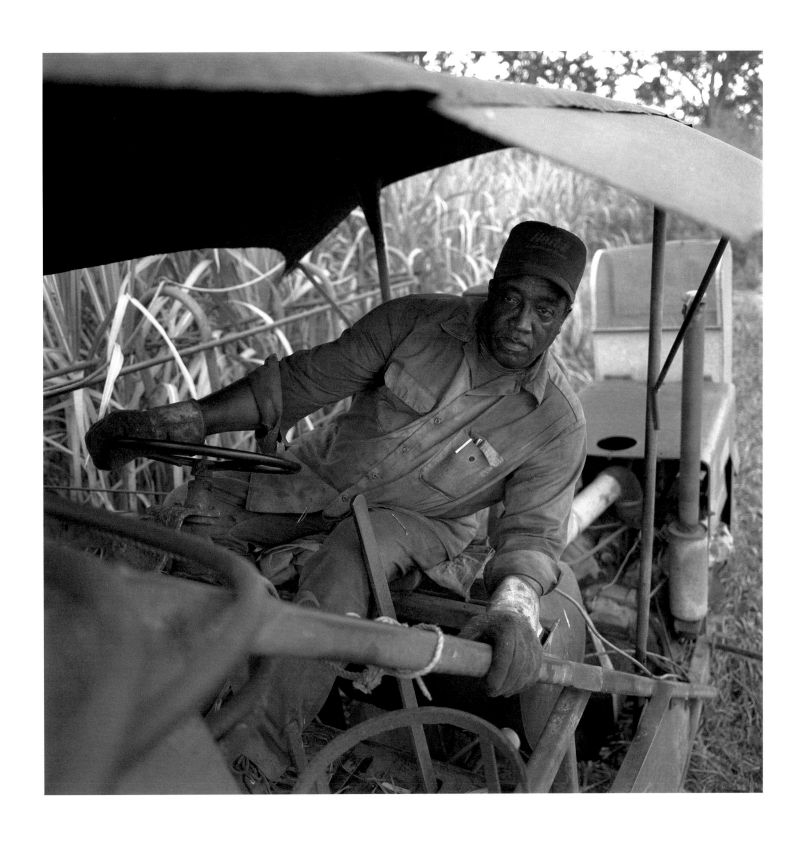

Cleveland Jackson    SAINT MARY PARISH, LOUISIANA

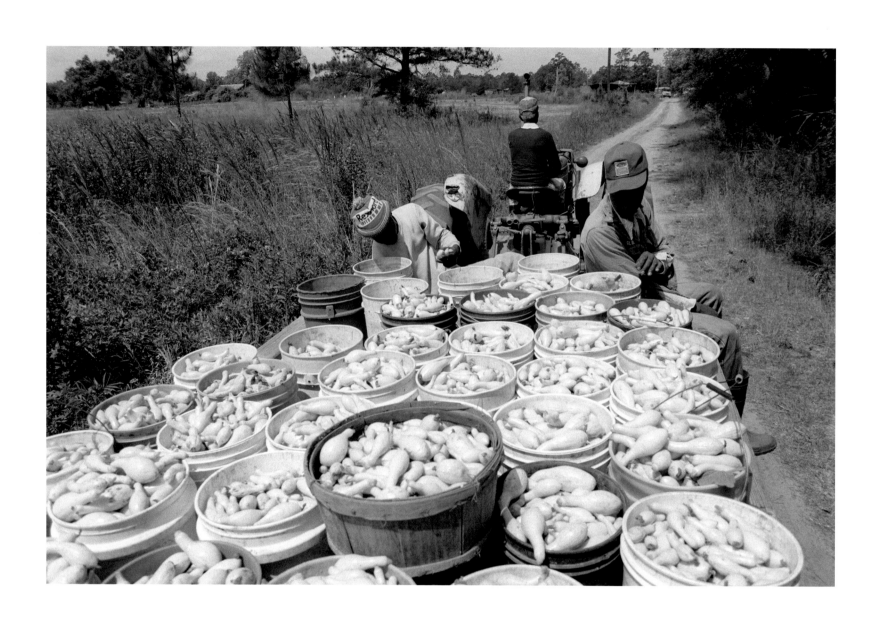

Freshly picked yellow squash   MARABLE FARM, THOMAS COUNTY, GEORGIA

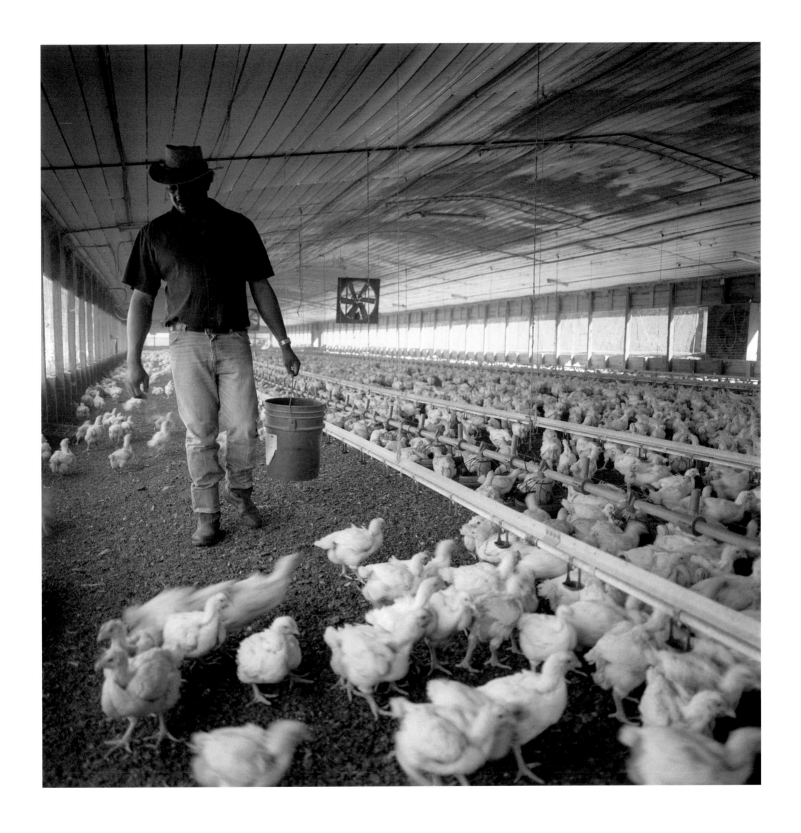

Willie Adams GREENE COUNTY, GEORGIA

"I expect it's just gonna
be a few farmers
and a whole lot of land."

**HERMAN LYNCH**   MARTIN COUNTY, NORTH CAROLINA

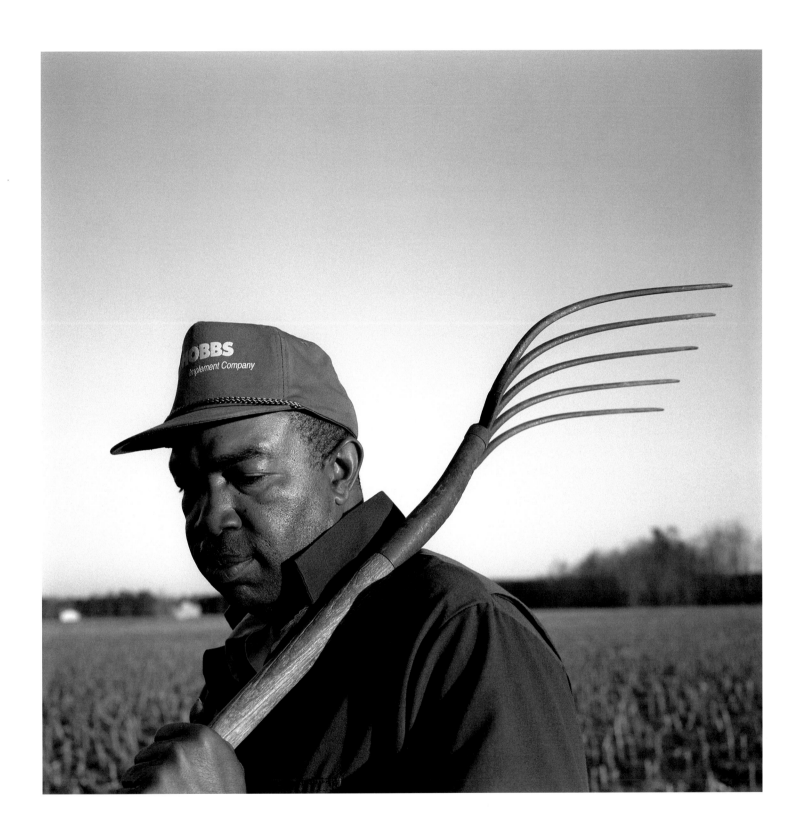

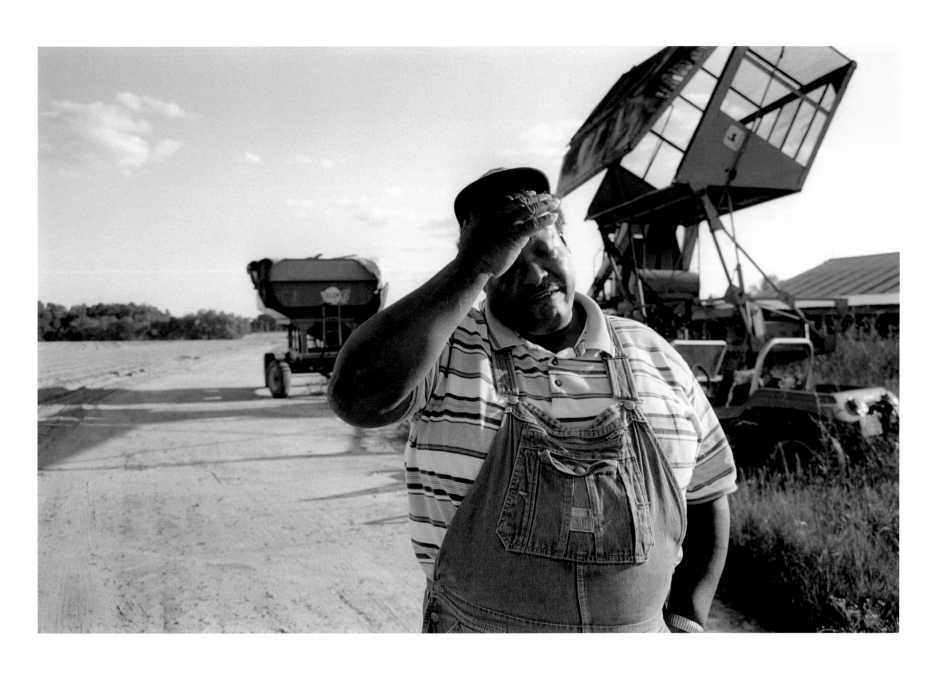

Carl Whitehead   DOOLY COUNTY, GEORGIA
*Overleaf:* Harold Wright   BLADEN COUNTY, NORTH CAROLINA

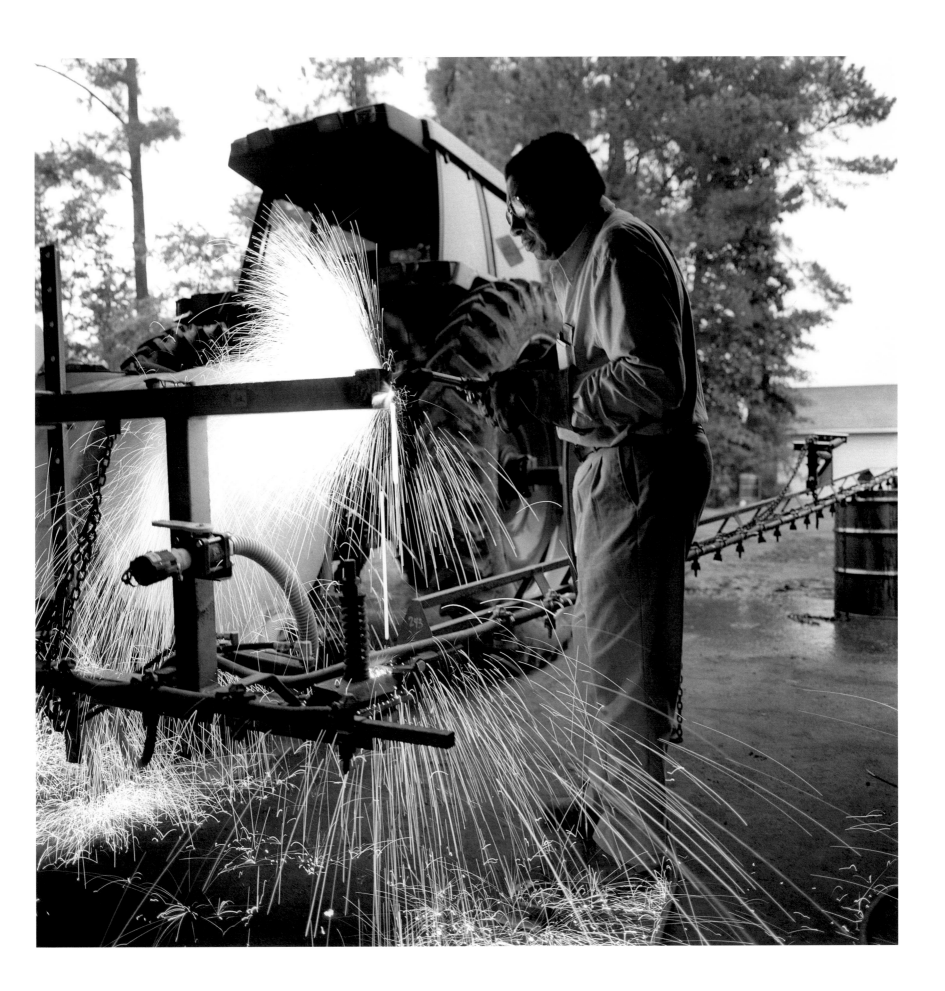

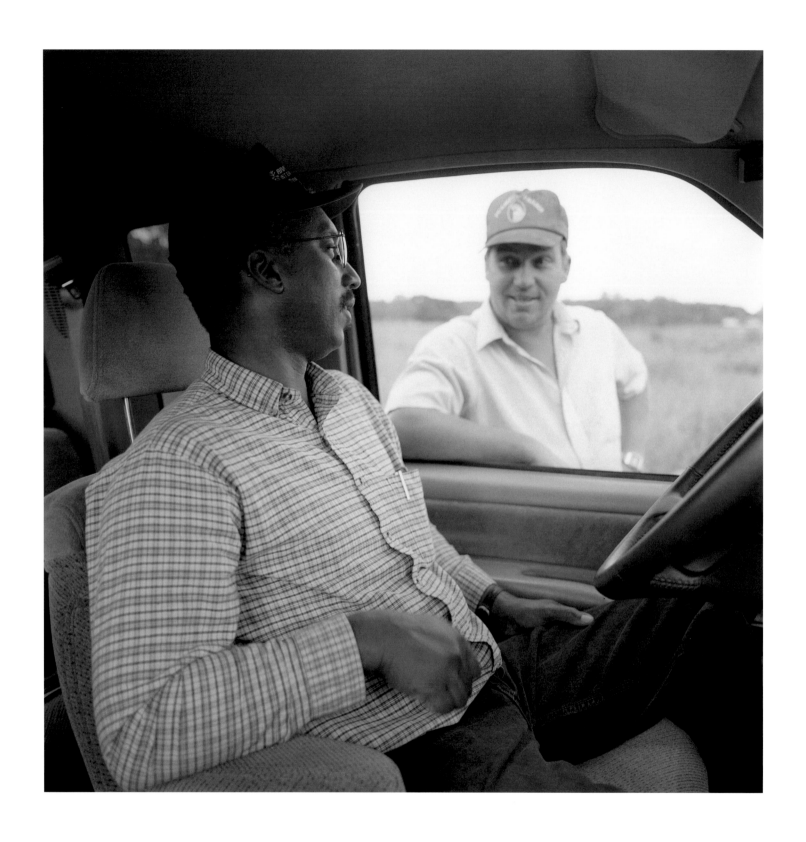

Warren James and neighbor   MACON COUNTY, GEORGIA

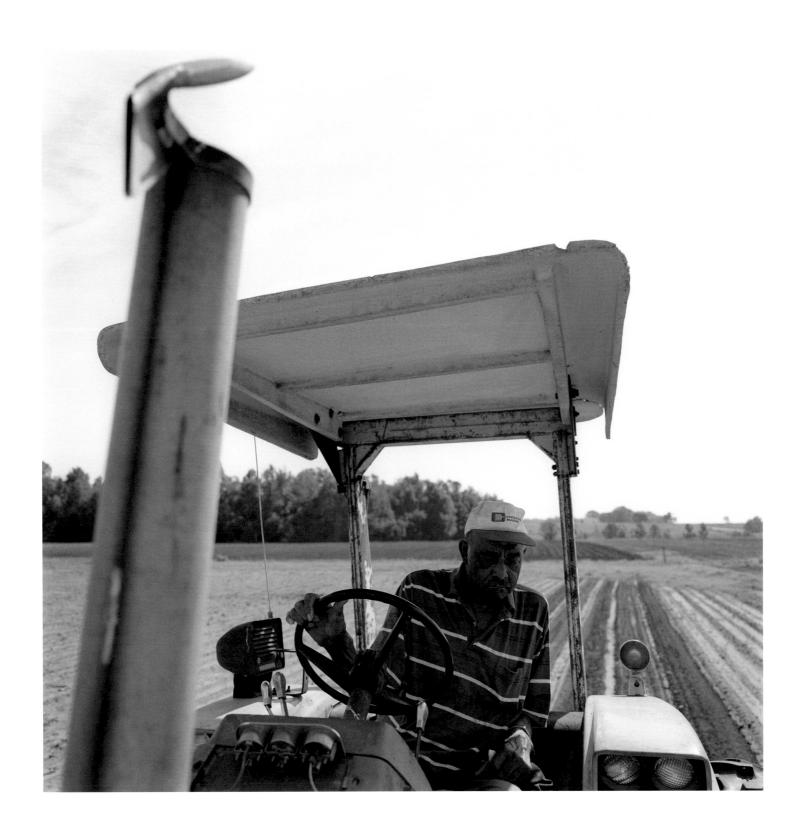

Hendley Bryant   DOOLY COUNTY, GEORGIA

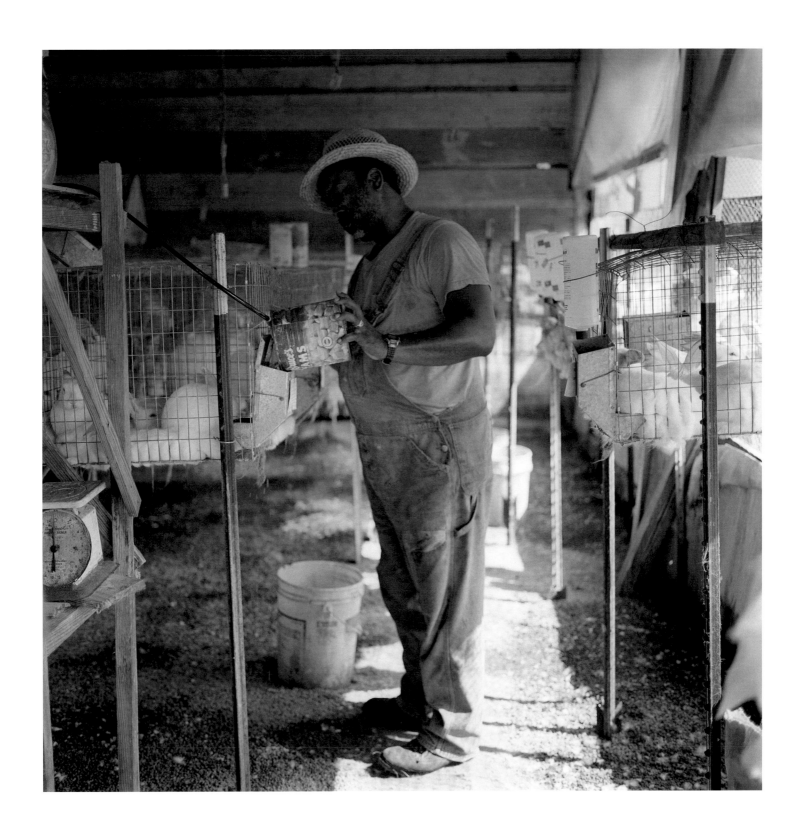

Toice Goodson   GREENE COUNTY, ALABAMA

"I am not an extravagant person,
I drive twenty-year-old equipment,
have an old car, and do not need
new things. Today's farms that are
family run can't support a higher
quality of life."

**ROY ROLLE**  MARION COUNTY, FLORIDA

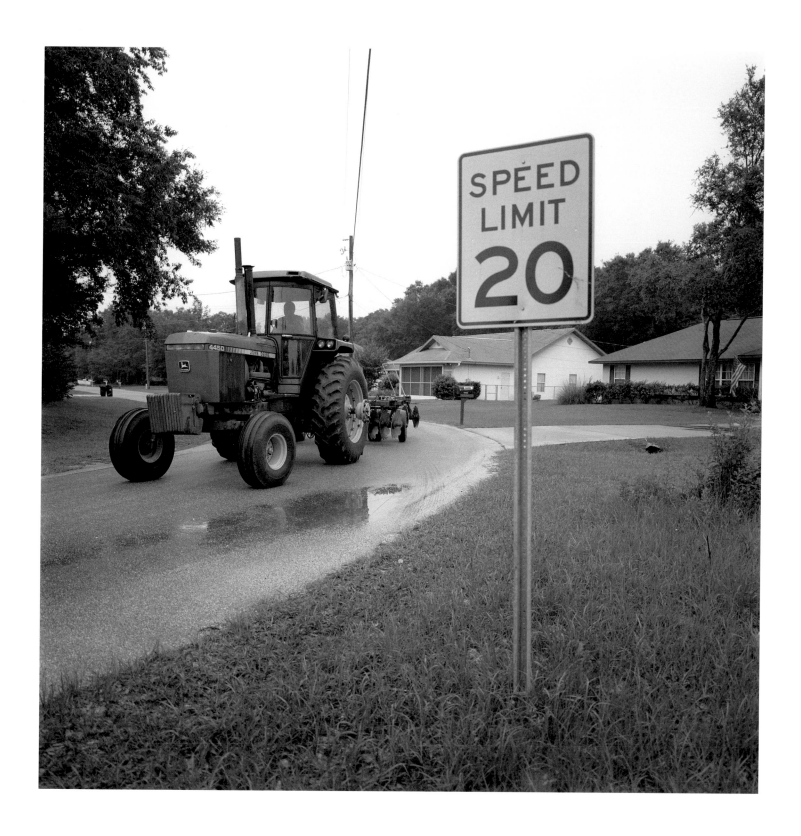

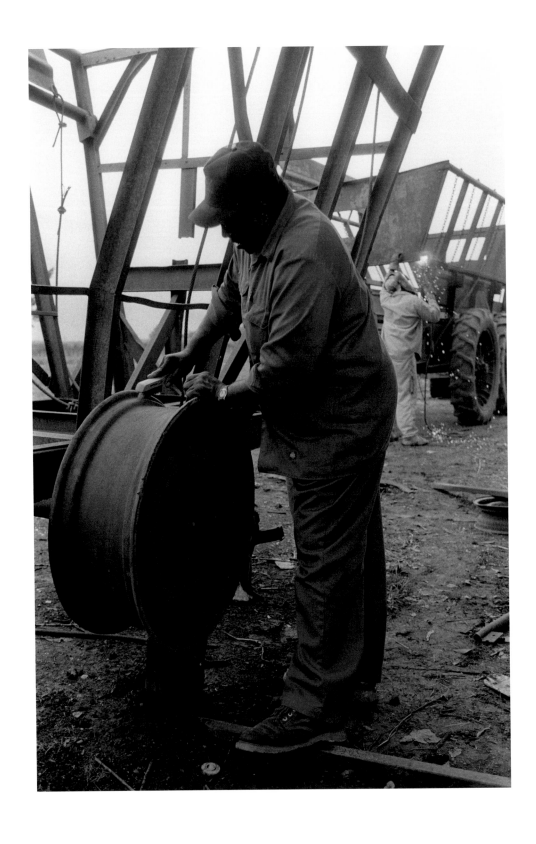

Cleveland Jackson repairing tire   SAINT MARY PARISH, LOUISIANA
*Right:* Warren James   MACON COUNTY, GEORGIA

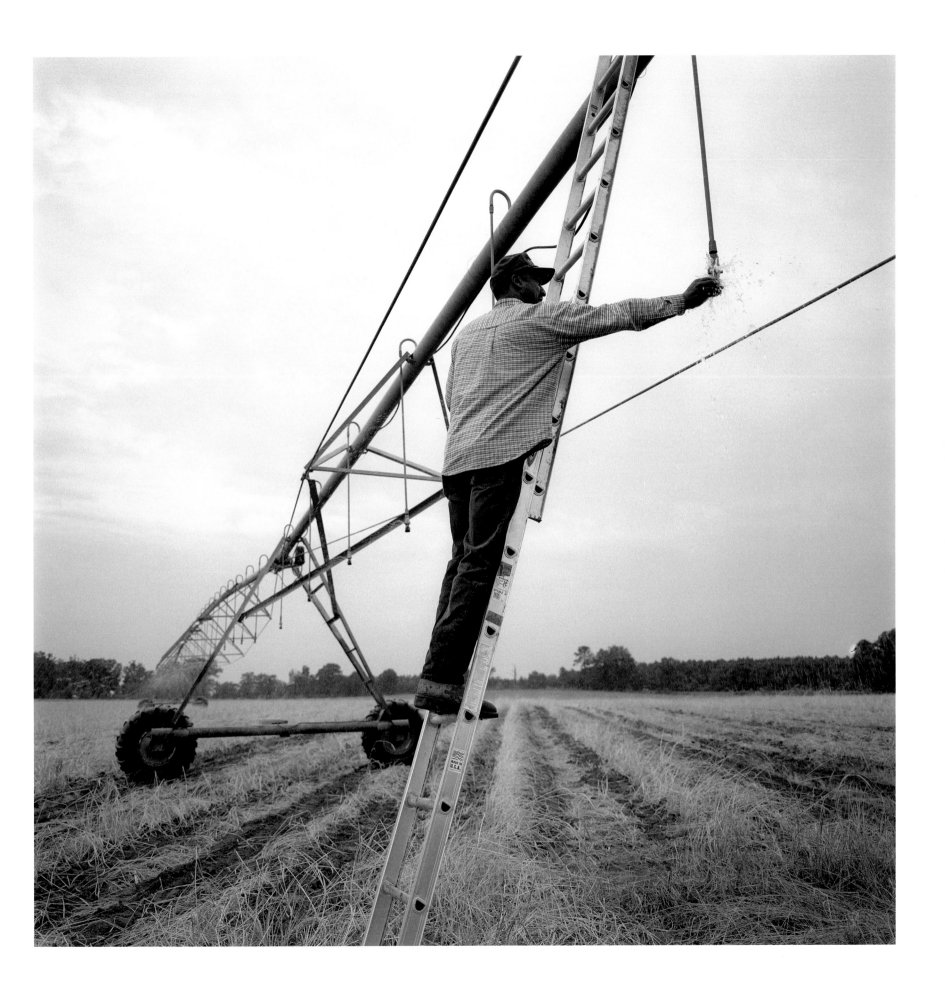

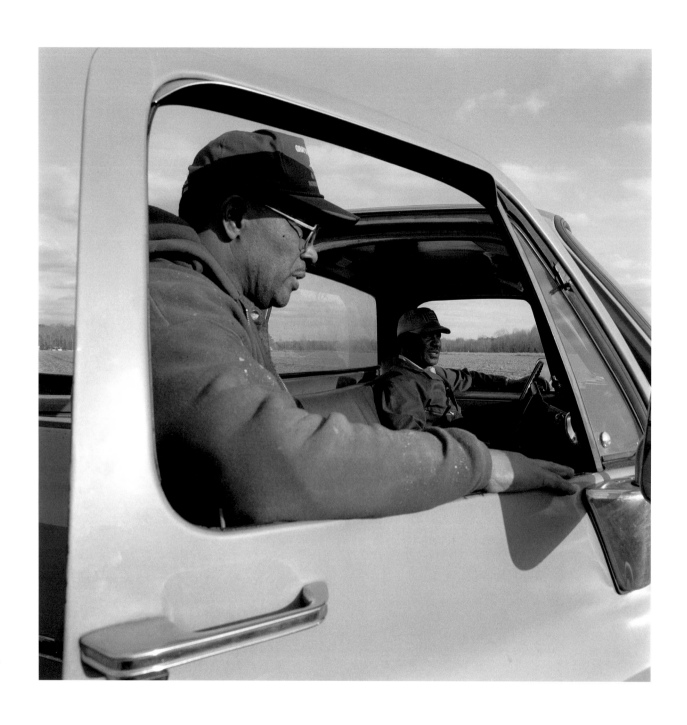

Starling and Ervin Bell   MARTIN COUNTY, NORTH CAROLINA

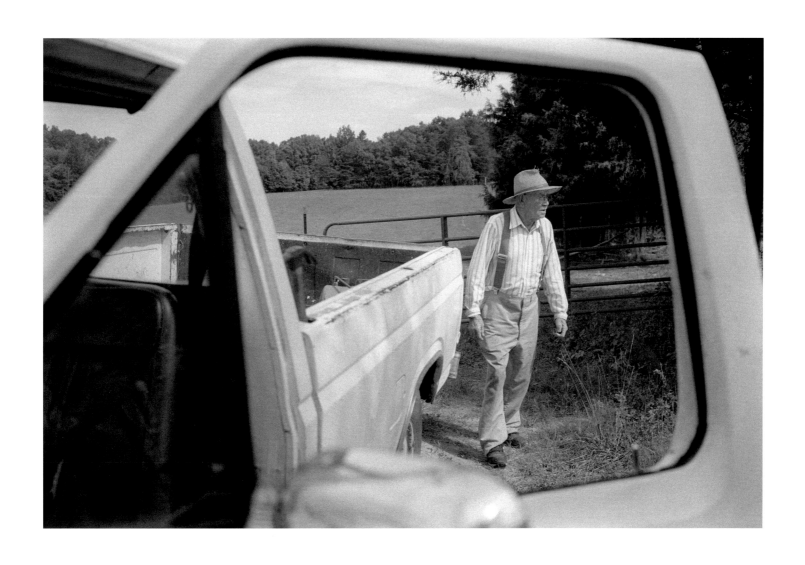

*Earl Jones*   BUCKINGHAM COUNTY, VIRGINIA

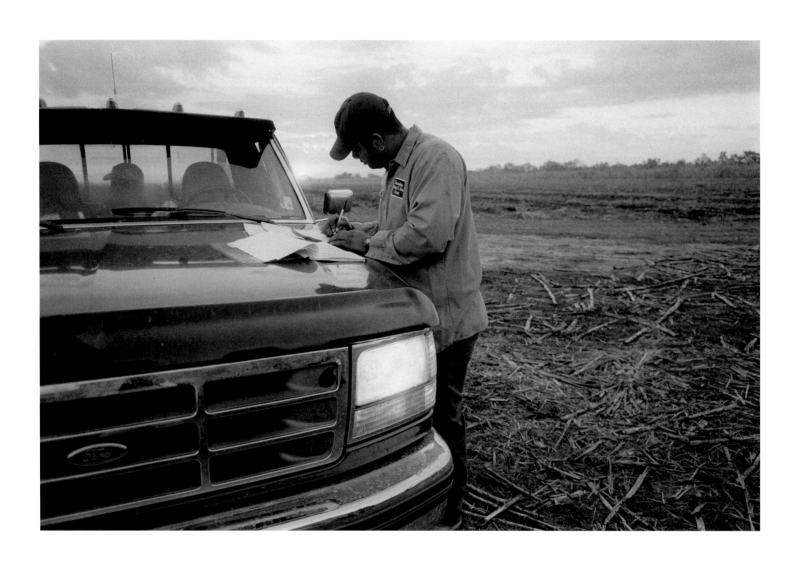

June Provost   IBERIA PARISH, LOUISIANA

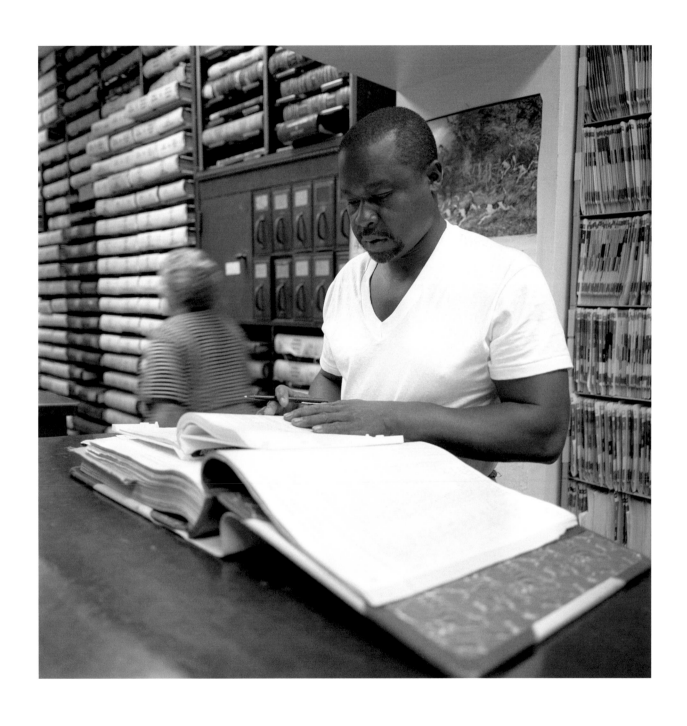

Willie Head  THOMAS COUNTY, GEORGIA

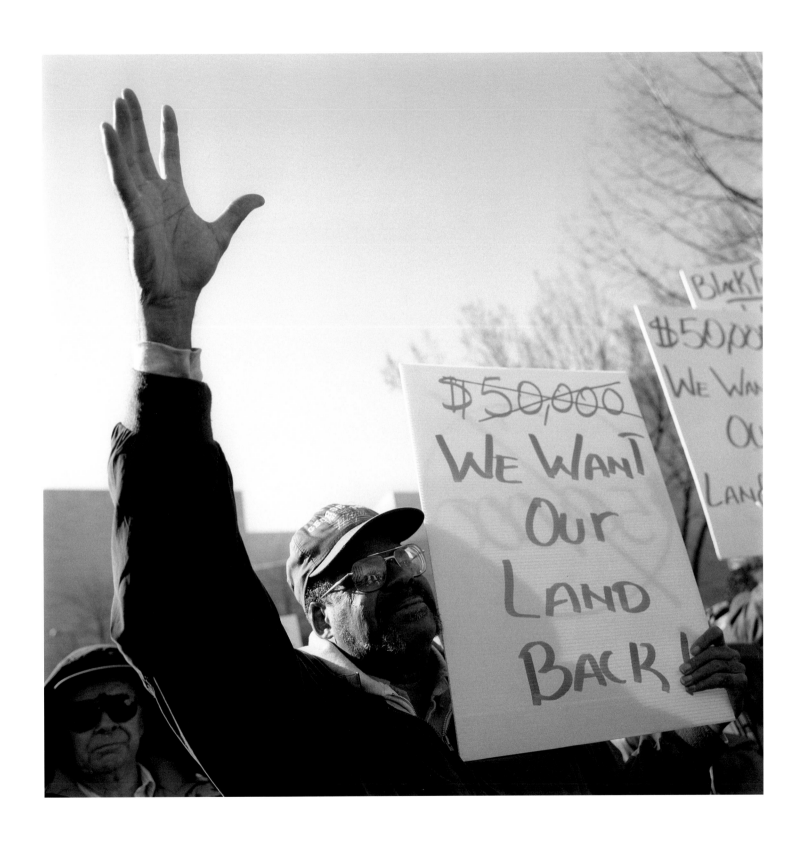

U.S. District Courthouse protest   WASHINGTON, D.C.

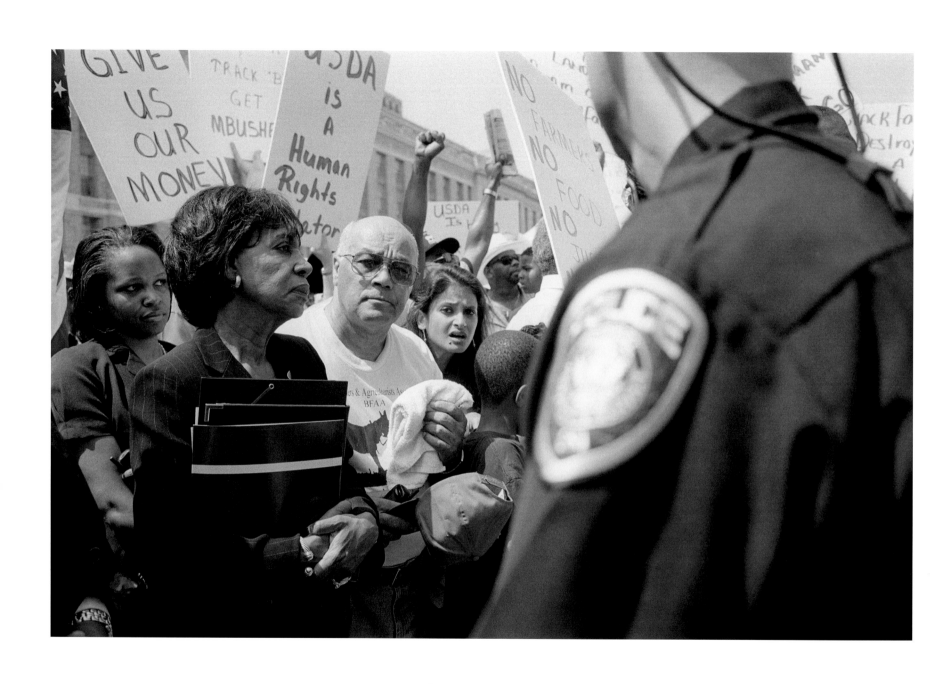

Maxine Waters, Gary Grant, and USDA protesters   WASHINGTON, D.C.

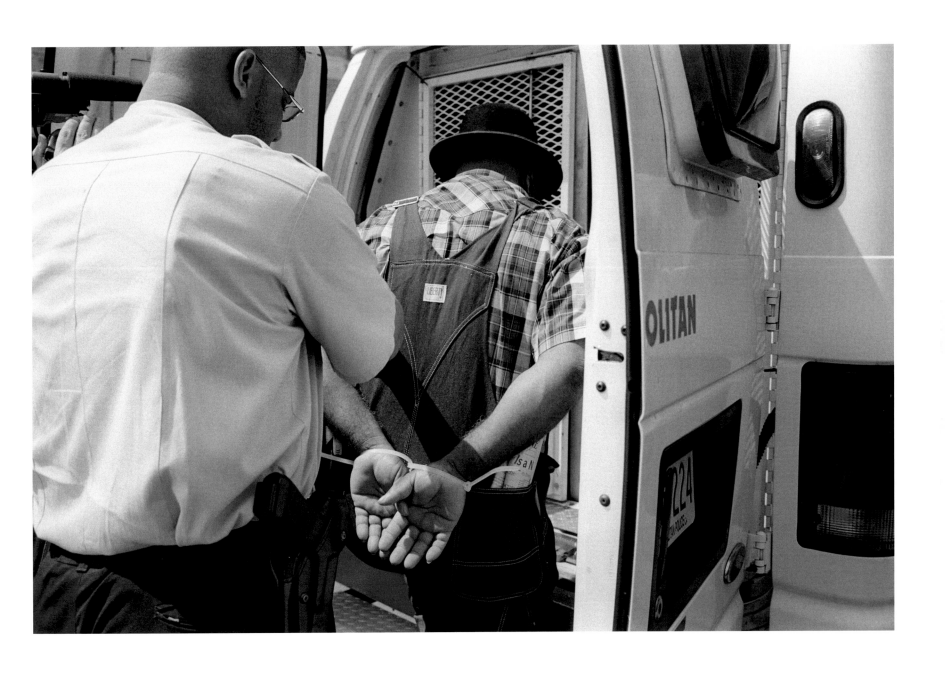

Arrest of USDA protester   WASHINGTON, D.C.

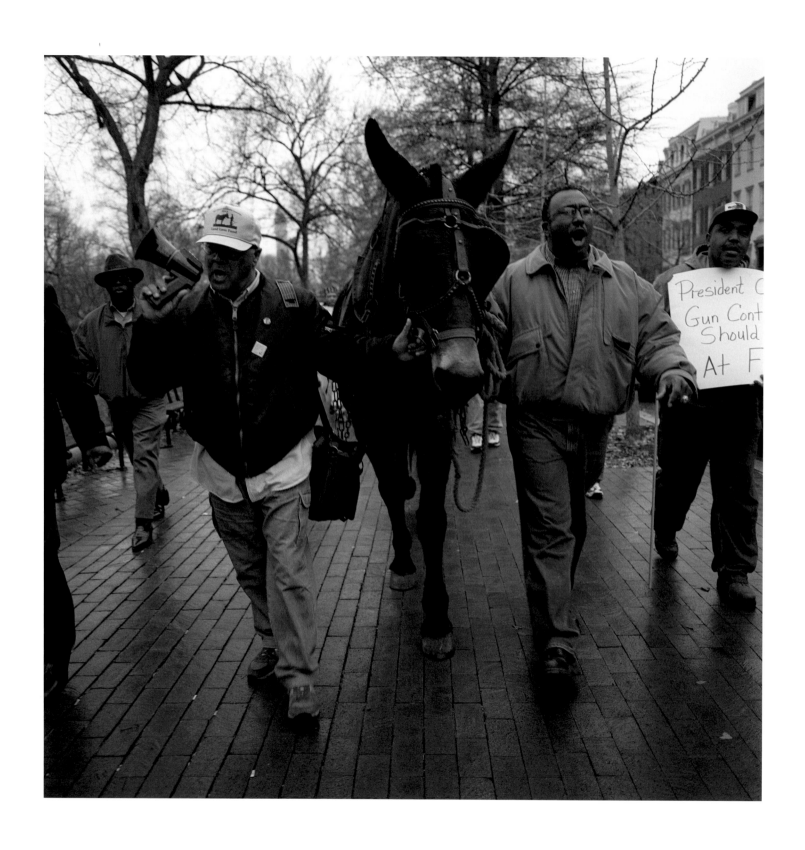

Gary Grant and John Boyd at Lafayette Park demonstration    WASHINGTON, D.C.

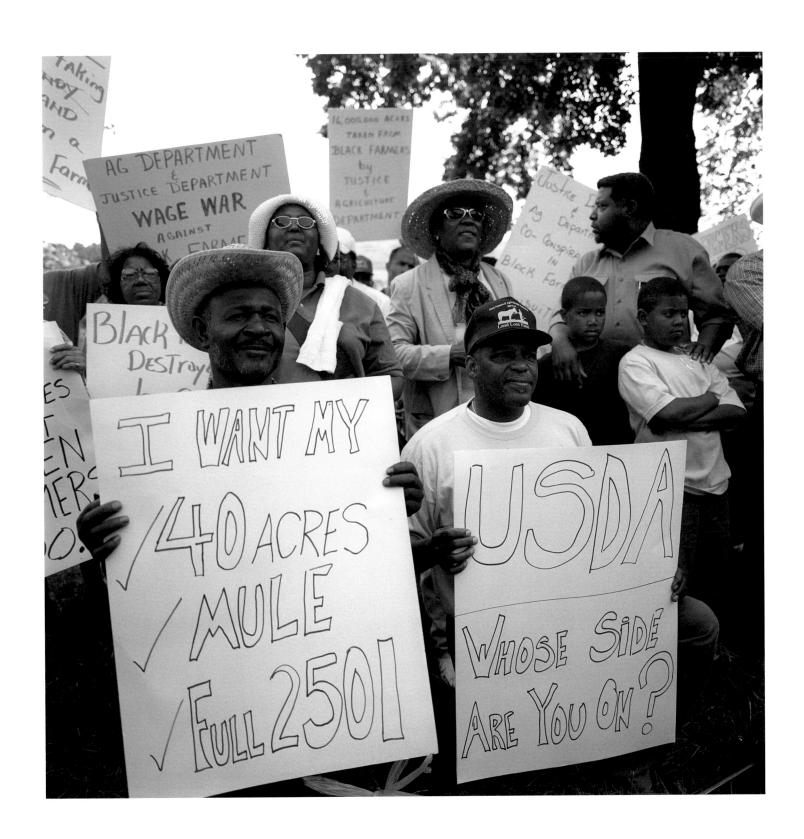

USDA protesters  WASHINGTON, D.C.

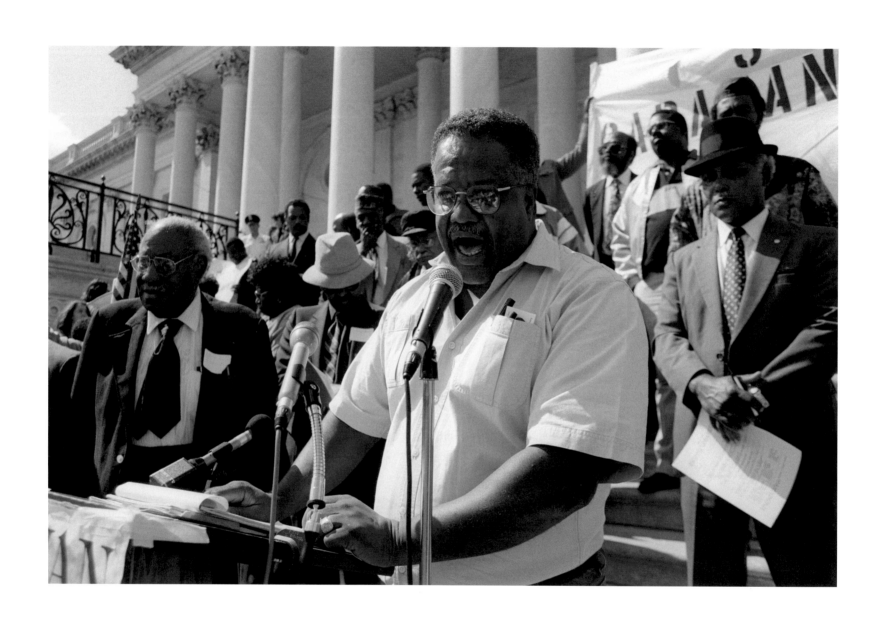

Ralph Paige at "Caravan to D.C." rally  WASHINGTON, D.C.

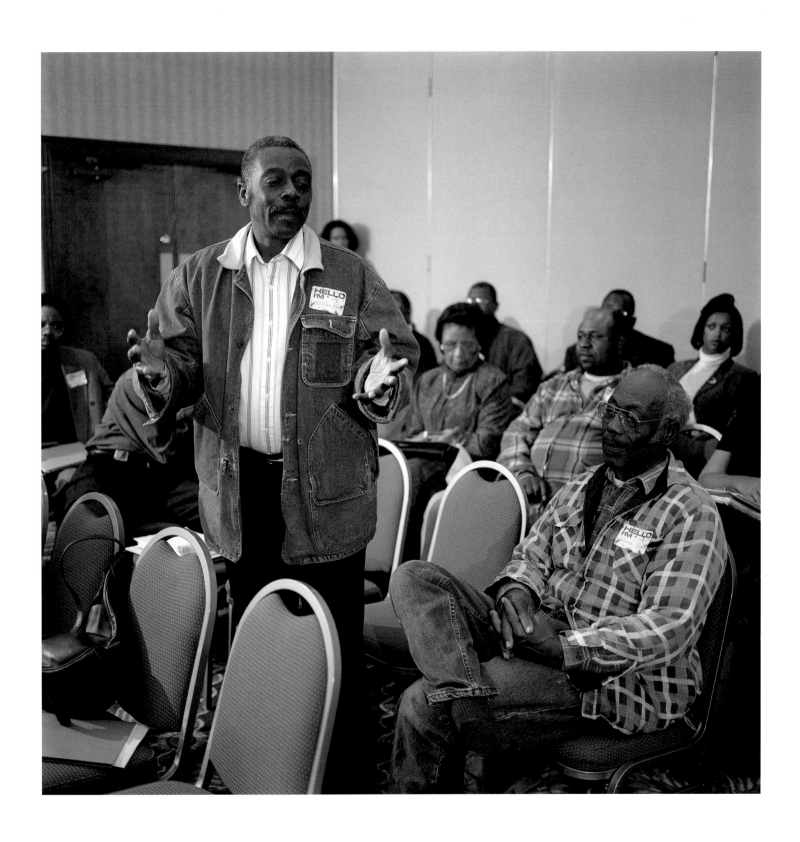

Open session at Land Loss Summit    DURHAM, NORTH CAROLINA

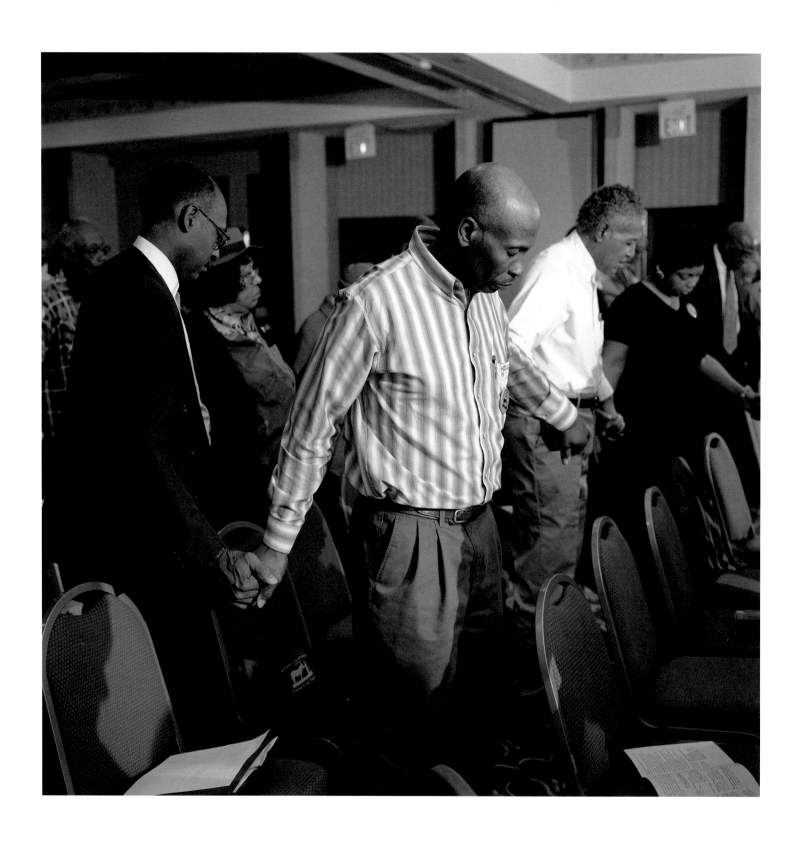

Opening prayers at Land Loss Summit   DURHAM, NORTH CAROLINA

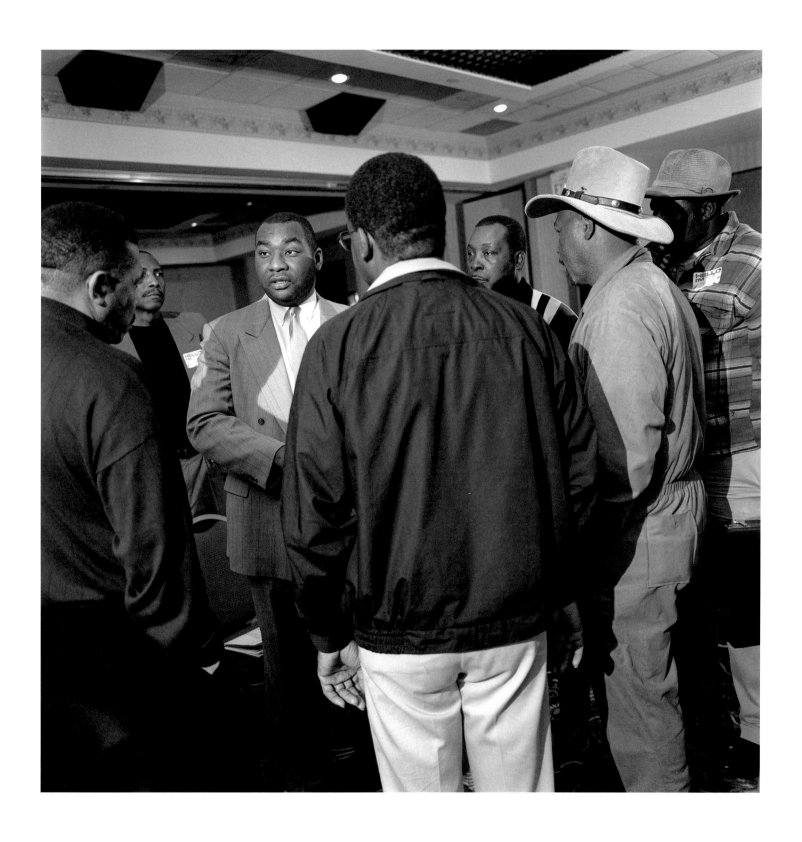

Stephon Bowens and Land Loss Summit participants   DURHAM, NORTH CAROLINA

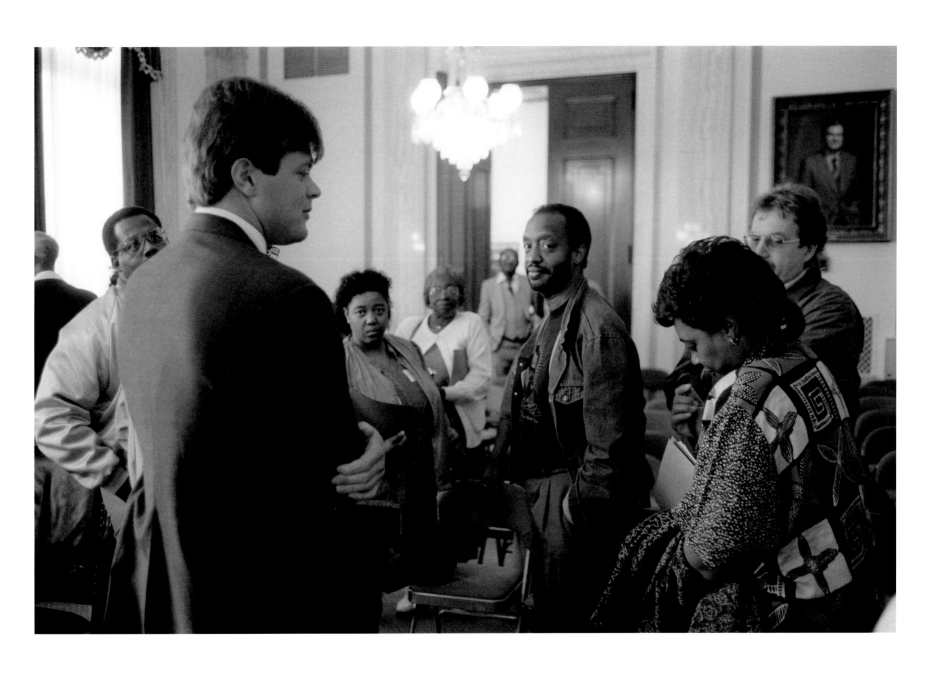

Shirley Sherrod and farmers meet with a congressional aide   WASHINGTON, D.C.

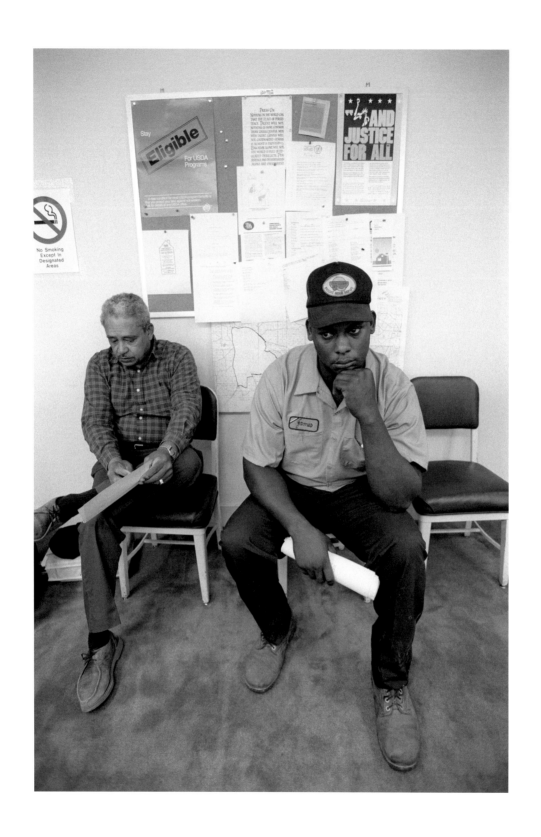

Gene Cummings and James Marable   THOMAS COUNTY, GEORGIA

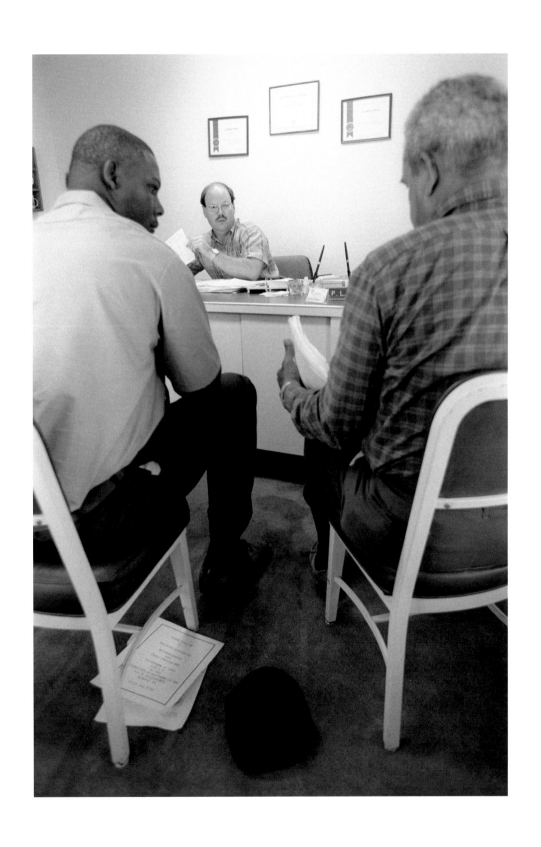

James Marable, USDA official, and Gene Cummings   THOMAS COUNTY, GEORGIA

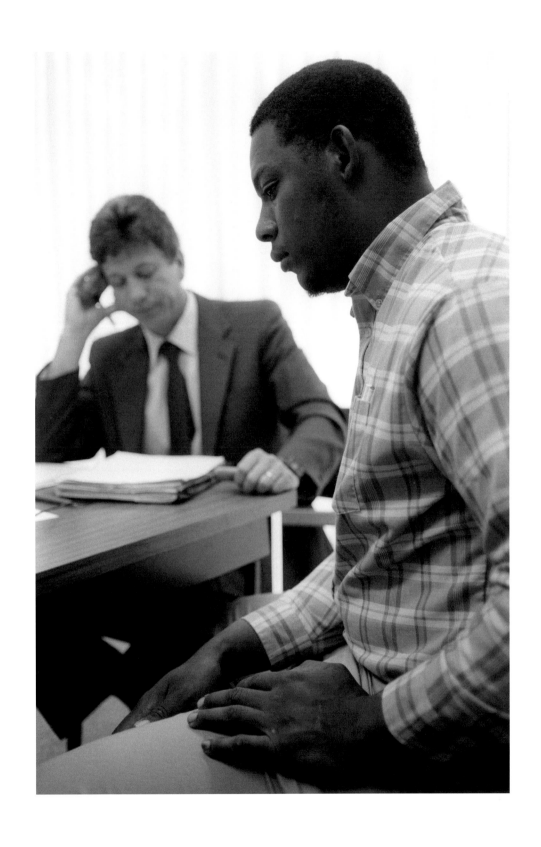

USDA official and James Marable  THOMAS COUNTY, GEORGIA
*Overleaf:* Joshua Davis  HOLMES COUNTY, MISSISSIPPI

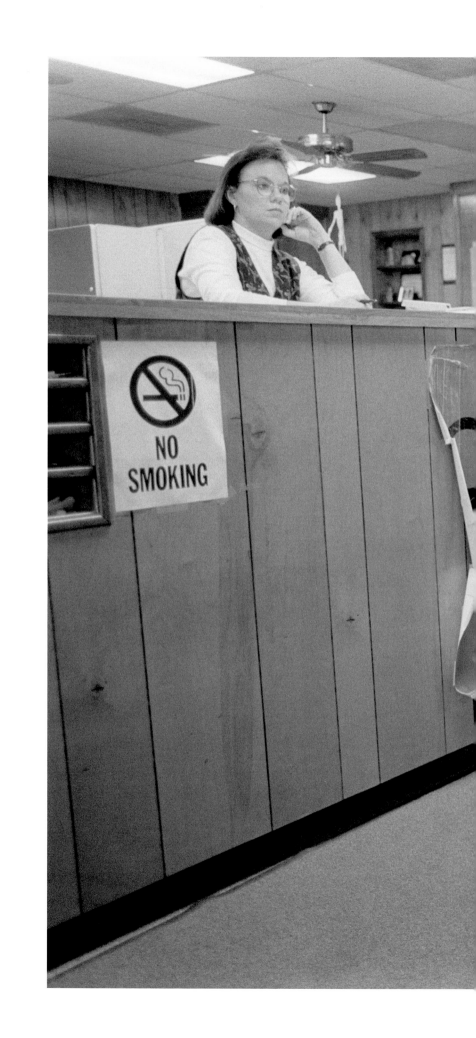

James Marable  MARABLE FARM, THOMAS COUNTY, GEORGIA

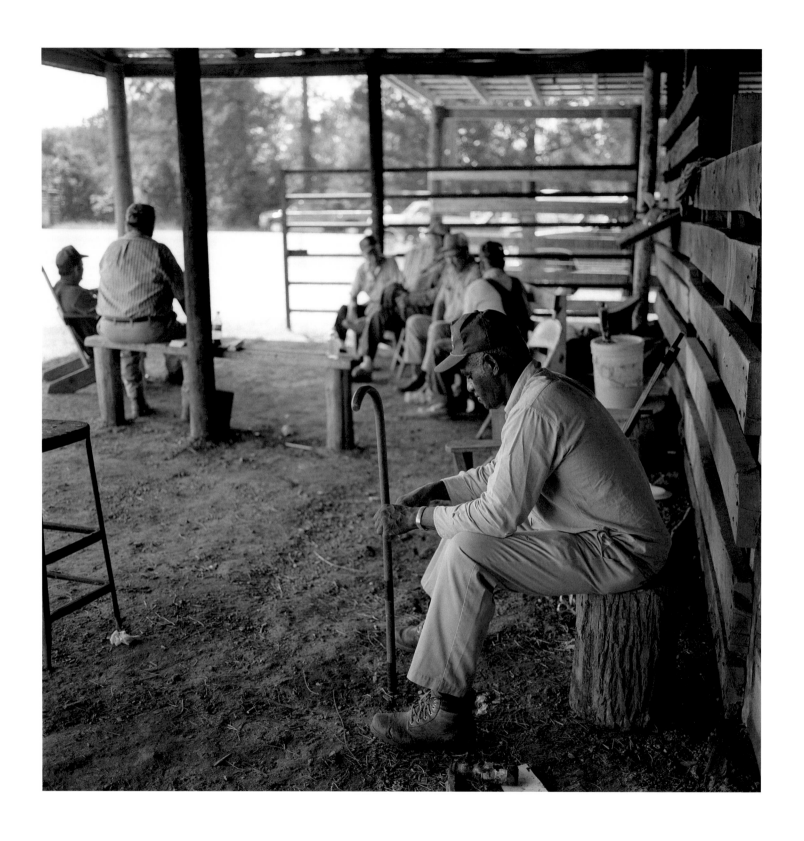

Cattle auction   GREENE COUNTY, ALABAMA

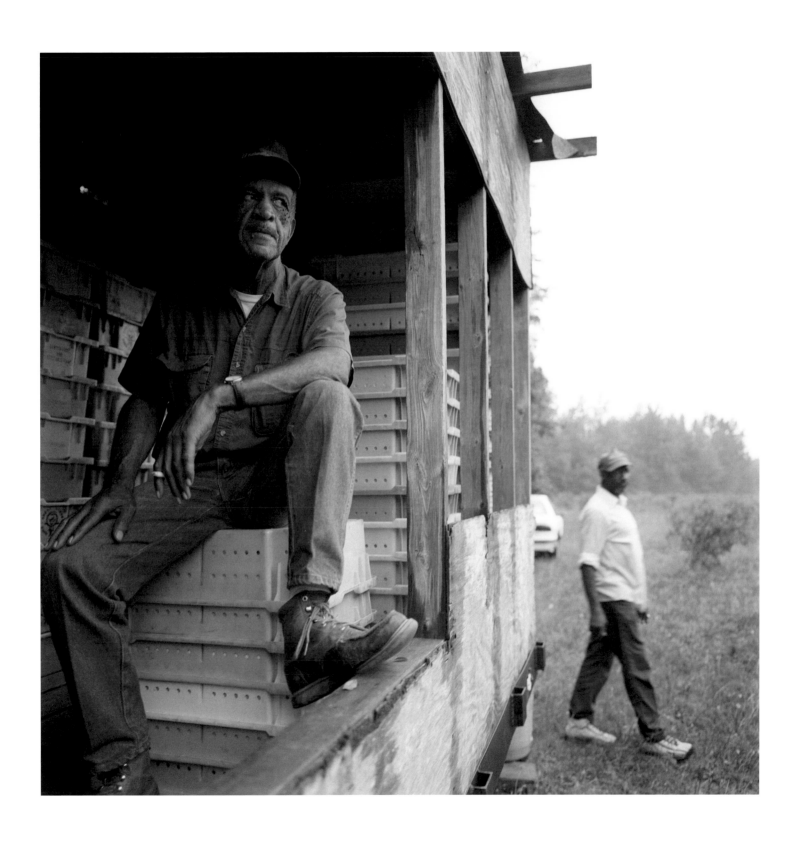

Doc Anderson   VAN BUREN COUNTY, MICHIGAN

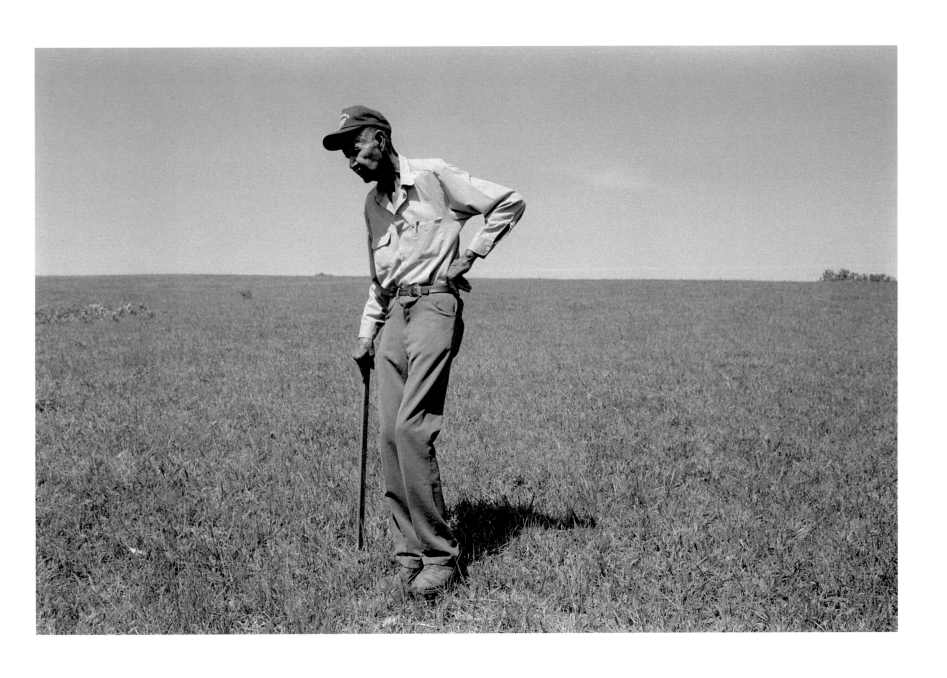

Madison Brown   BUCKINGHAM COUNTY, VIRGINIA

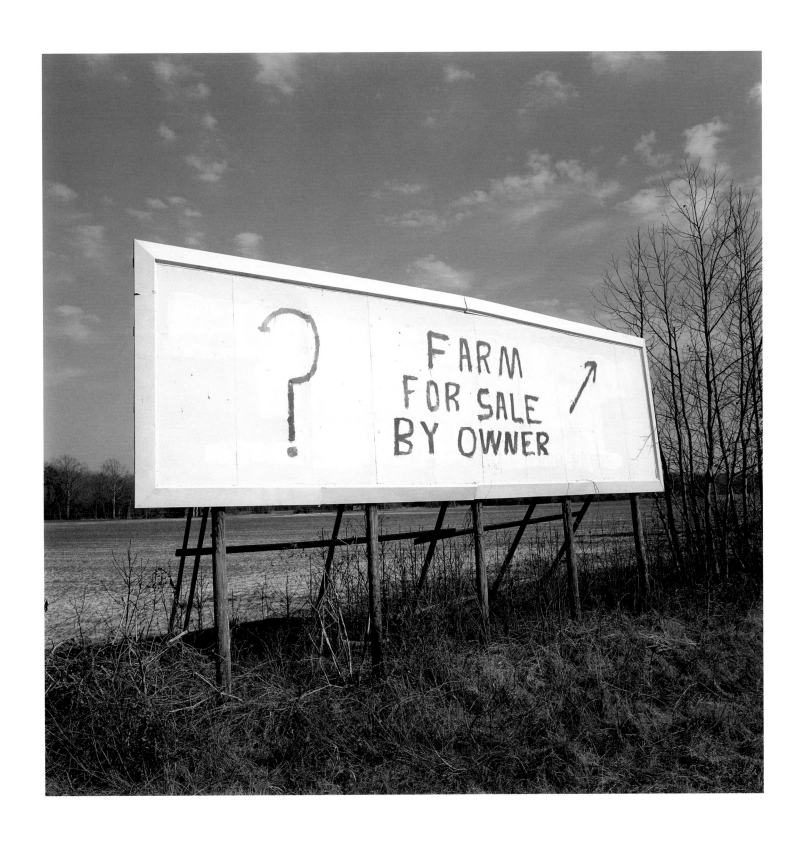

"Farm for Sale"  HALIFAX COUNTY, NORTH CAROLINA

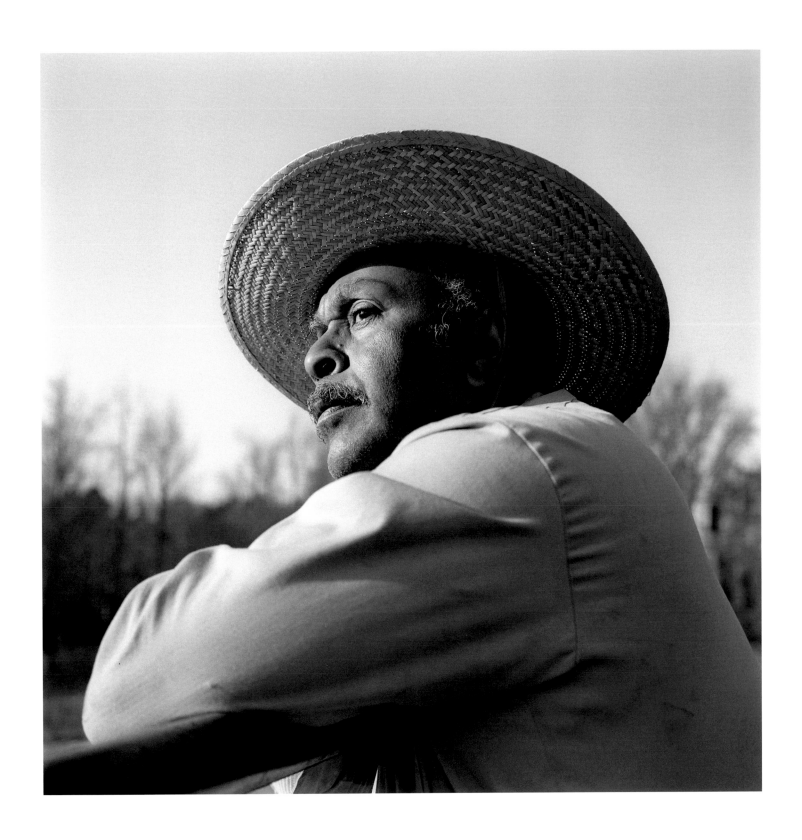

Jeff Hawkins    WARREN COUNTY, NORTH CAROLINA

"The whole state is biased. Even
when the loan was finally approved
the check was lost in the mail
for several months so I was unable
to even start my crops."

**EDDIE CARTHAN**  HOLMES COUNTY, MISSISSIPPI

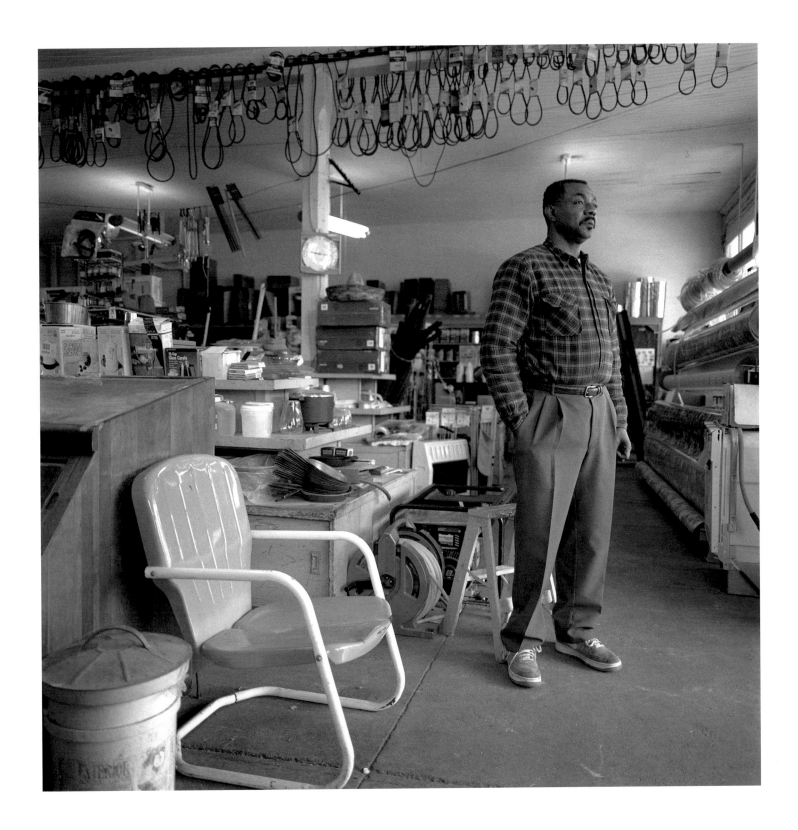

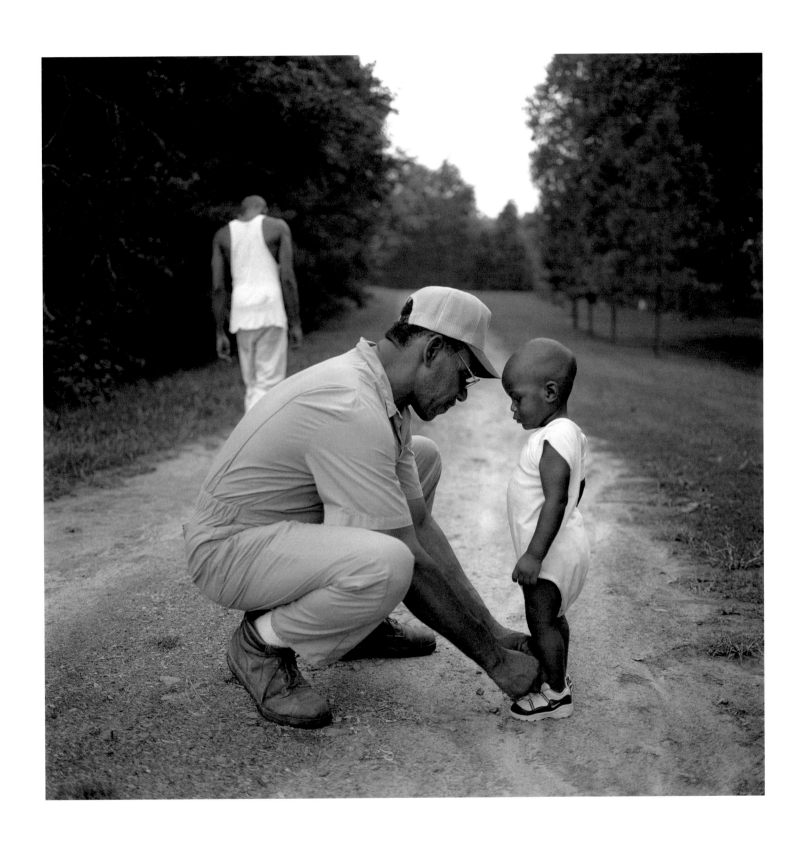

Louden Marshall with grandson Cullen as son Louden III walks away   CUMBERLAND COUNTY, VIRGINIA

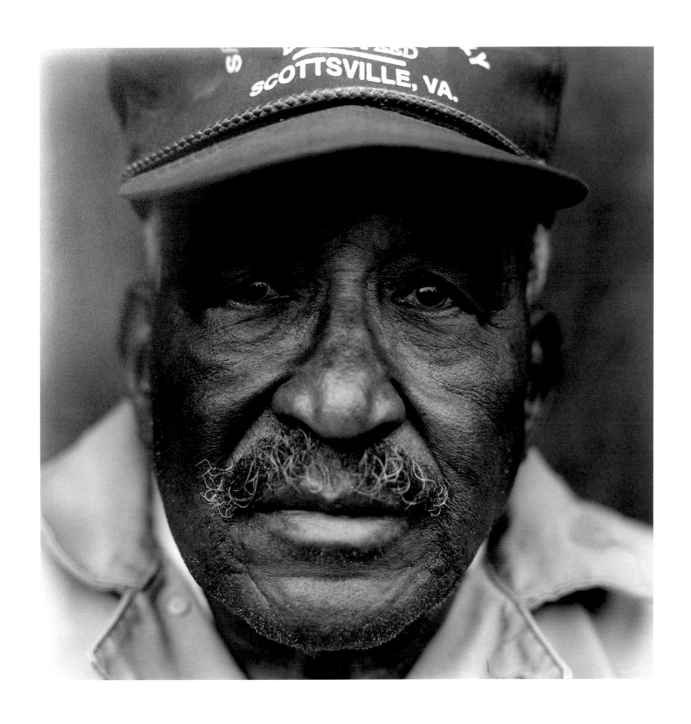

Allen Gooden   BUCKINGHAM COUNTY, VIRGINIA

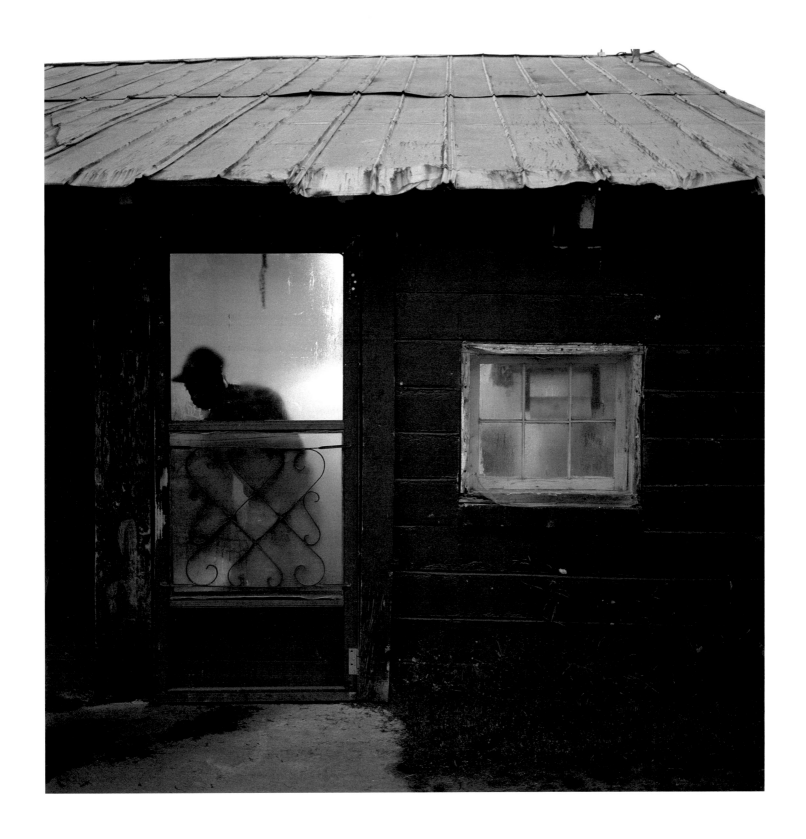

Roger Lamar in the milk house   PUTNAM COUNTY, GEORGIA

Deserted farmhouse   GREENE COUNTY, ALABAMA

# Captions

**i  Cotton seed**
HALIFAX COUNTY, NORTH CAROLINA

**ii–iii  Cotton field**
DOOLY COUNTY, GEORGIA

**iv  David Singleton**
LEE COUNTY, ALABAMA
David Singleton, a third-generation produce farmer, worked his small farm on a part-time basis while also holding another job until heart disease prevented him from engaging in any strenuous labor. He currently helps his brother Jerry with minor field chores.

**vii  Blueberry pickers in the early morning** (detail)
VAN BUREN COUNTY, MICHIGAN

**x–xi  Edmond Clark**
HUMPHREYS COUNTY, MISSISSIPPI

**xv  Rosa Murphy**
BROOKS COUNTY, GEORGIA

**1  Griffen Todd**
WAKE COUNTY, NORTH CAROLINA
Griffen Todd, a third-generation farmer, grows tobacco and soybeans and raises hogs. "I grew up on a farm and have been farming all my life. I believe the man upstairs looked over this farm and my family. The hardest part of farming here has been working with people who don't want to see you succeed." His son Griffen Jr. is taking over the farm.

**2  Hay rolls**
GREENE COUNTY, ALABAMA

**3  George Jackson**
LAKE COUNTY, FLORIDA
George Jackson, a third-generation farmer, is the son and grandson of cotton sharecroppers. One of the last small citrus farmers, George grows oranges and grapefruit naturally, without the use of herbicides. In many parts of Florida he is known simply as "Shouting George," a nickname given to him by fellow parishioners during prayers at church, where he is a deacon. He is a last-generation farmer.

**4  Cotton field**
HUMPHREYS COUNTY, MISSISSIPPI

**5  Belinda, Jonathan, Roger, and Kendra Lamar**
PUTNAM COUNTY, GEORGIA
A third-generation farmer, Roger Lamar leads his family in prayer before supper. He followed his father into dairy farming (his grandfather used the farmland for row cropping). Having trouble finding helpers in the area, Lamar chose to have a smaller, more manageable operation that he can handle himself with occasional help.

**6–7  Preparing the field**
DOOLY COUNTY, GEORGIA

**9  Matthew Grant**
HALIFAX COUNTY, NORTH CAROLINA
Matthew Grant pauses on a dirt road after Sunday church service. A plaintiff against the USDA, Grant died before receiving any settlement.

**10  Rosa and Eddie Murphy**
BROOKS COUNTY, GEORGIA
Rosa Murphy strokes her husband's forehead while sitting on their front porch after dinner. The daughter of sharecroppers, she grew up working with her parents on a plantation when not in school. She married Eddie, a fellow child of sharecroppers on the same plantation, and they worked as sharecroppers as well. Eventually, they saved enough money to purchase their own farm in a different county.

Eddie suffered a stroke in 1982, leaving him blind. A typical day for Rosa begins with waking and tending to her husband, serving breakfast, and placing him in his chair on the front porch. Leaving him with a telephone and pitcher of water at his side, Rosa heads out to tend her fields. She returns to serve the midday meal and then rests for a while.

**11  Kendra Lamar**
PUTNAM COUNTY, GEORGIA
Kendra Lamar helps to hand-feed two young calves during afternoon chores.

**12  Elton "Li'l Bro" Williams**
MARABLE FARM, THOMAS COUNTY, GEORGIA

**13  Carranza Morgan Sr.**
SUMTER COUNTY, GEORGIA
Carranza Morgan Sr., now deceased, was a third-generation farmer who grew row crops. In 1886 his grandfather Milton Morgan purchased the family farm, which has been passed down and farmed by each successive generation. Since Carranza's passing, his children continue to own and operate the farm.

**14  Alice and Ron Burton**
MARION COUNTY, FLORIDA
Alice and Ron Burton set up their farm stand on weekend mornings in downtown Ocala. Ron has farmed both part- and full-time over the years since he was old enough to drive. He now devotes all his time to the occupation with his wife, saying, "I enjoy watching the plants grow and mature. I am interested in the marketing of each type of crop. For me it's a emotional experience."

**15  Fred and Phillip Perry**
SCHLEY COUNTY, GEORGIA
Fred and Phillip Perry bag produce for a customer at their roadside produce stand.

**16  Hendley Bryant and William Lawson**
DOOLY COUNTY, GEORGIA
Hendley Bryant stops to talk with neighboring farmer William Lawson. Bryant, a second-generation farmer who inherited land from his father, added acreage for his cotton, vegetables, and peanuts.

**17  Ulyess Blackmon**
HENRY COUNTY, ALABAMA
Ulyess Blackmon, a third-generation farmer, is an institution known to all at the farmers market in front of the courthouse, where he sells his produce from the back of his truck on weekends. He began farming with his father at the age of seventeen, but worked full-time for the phone company after high school. When his father died, Ulyess took over the family farm, having always admired the way his father had built up the operation. "Farming is all I really ever wanted to do. I have always been an independent person, and farming allowed me that independence. My father grew peanuts and cotton and I slowly got out of that because the government controlled too many aspects of those crops. I started planting more produce to get away from the government controls." Blackmon will be the last generation to farm his land.

**19  John and Evelena Burton**
MARION COUNTY, FLORIDA
A second-generation farmer, John Burton grows and handpicks Valencia peanuts with the help of his wife, Evelena. Because the peanuts grow on the roots, the

farmers must first pull the plant from the soil before picking the shells. The difficult technique strains back muscles and fingers, as is evident when Evelena stretches her hand after working in the field for several hours. Says John, "For many years I walked behind horses. Got a tractor and it made it a little easier."

**21 Rosa Murphy**
BROOKS COUNTY, GEORGIA
Rosa Murphy, in her late eighties, continues to do light work in her fields.

**23 Eddie Cole**
GREENE COUNTY, ALABAMA

**24 Sugarcane harvest**
SAINT MARY PARISH, LOUISIANA
Cleveland Jackson (center) pulls sugarcane stalks from his old harvester with the help of his cousin and a neighbor. The decrepit machine frequently jams, which translates into time lost removing the sugarcane from the fields.

**25 Tobacco harvest**
BUCKINGHAM COUNTY, VIRGINIA
Hoover Johnson, a third-generation farmer, stacks tobacco leaves atop a wagon as friends, relatives, and neighbors help during peak seasons. Johnson's ancestors were sharecroppers until his father bought the family's first farm; however, his three sons work off the farm and are unsure if they will continue the tradition.

**27 Eddie Cole**
GREENE COUNTY, ALABAMA
Eddie Cole pauses in his field with his basket of freshly picked beans. The fourth generation to work the family farm and a music teacher in the Sumter County school district, he relies on friends and family during peak harvest season and occasionally resorts to hiring help to get produce out of the fields in time. He says of his struggles, "[Farmers] can't seem to benefit from increased prices at the top. Prices for produce bushels have pretty much remained the same. Small farmers are struggling and black farmers struggle with financing and loans. I had to sell two cows [out of twenty] to put seeds in the ground."

**29 Mitchell Brambly**
CASS COUNTY, MICHIGAN
Mitchell Brambly delivers bales of hay to cattle in his fields as a snowstorm approaches. The son and grandson of sharecroppers, Mitchell bought his farm while working for the railroad, which he eventually left so that he could farm full-time. He is a last-generation farmer.

**30 Virgil Pullins and local high school football players**
MARION COUNTY, FLORIDA
Virgil Pullins leaves his field with a wagonload of watermelon. Pullins gets help from the local high school team's football players; they pick and carry the melons from the field to begin preseason football training. Pullins is a last-generation farmer.

**31 Willie Head and neighbors**
THOMAS COUNTY, GEORGIA
Willie Head, a third-generation farmer, carries his

watermelon crop from the field with the help of some neighbors. Head's father grew tobacco and produce, and his grandfather grew tobacco and raised cows on the same land. A last-generation farmer, Head has started a hog operation on the farm and grows corn as well, having decided to phase out tobacco and watermelon.

**32 Produce harvest**
MARABLE FARM, THOMAS COUNTY, GEORGIA

**33 Ron and Alice Burton**
MARION COUNTY, FLORIDA

**34 Joe Haynes Jr.**
MARION COUNTY, FLORIDA
Joe Haynes Jr. is a third-generation farmer on land passed down from his grandfather. He raises hogs and has a few cows; his children will continue to work the land.

**35 Charles Williams**
SUMTER COUNTY, ALABAMA
Charles Williams, a third-generation farmer, formerly grew only produce on a part-time basis. Since retiring from his other job, he now farms full-time, having added cattle to the produce operations. The land was bought by his grandfather, who derived all his income from it, and taken over by his father, who worked the land on both a part- and full-time basis over the years. Williams will pass the farm down to his sons.

**36 Homer Gary**
MARION COUNTY, FLORIDA
Homer Gary moves his cattle to a fresh pasture.

**37 Harry and Donald Means**
GREENE COUNTY, ALABAMA
Third-generation cattle farmer Harry Means and his son Donald walk through a pasture looking for one of their large breeding bulls that continues to break out of fenced spaces. Harry, who is in his seventies, can no longer control the 2,600-pound bull. They have been trying for days to herd the bull into a trailer for transport to the Greene County stockyards, where it will be auctioned.

**39 Hoover Johnson**
BUCKINGHAM COUNTY, VIRGINIA
Weeks after removing tobacco from the field, Hoover Johnson inspects some tied leaves that have been curing. Unlike new tobacco barns constructed of metal and heated with gas, Johnson's wooden barn uses a large smoldering log for heating and curing.

**40 Jessie Caver**
CHILTON COUNTY, ALABAMA
After making the one-hour drive from his farm to the Birmingham, Alabama, farmers market every weekday morning, Jessie Caver, shown here at 4:30 A.M., waits for fresh produce buyers in a rented stall. Returning to the farm around 10:30 A.M., he works until sunset on the same ground farmed by his father and grandfather, who purchased the land.

**41 Levi Morrow**
GREENE COUNTY, ALABAMA
Levi Morrow, a third-generation farmer, records the numbers of tagged cattle he will bid upon at the Greene County stockyards auction. His grandfather purchased the farm and had a few cattle, but mostly row cropped; Morrow's father discontinued the row crops and made the farm strictly a cattle operation. Levi, who continues in this vein, has added the land he purchased from his in-laws, expanding his holdings to 233 acres. He is a last-generation farmer.

**42 Lamar family milking barn before dawn**
PUTNAM COUNTY, GEORGIA

**43 Roger and Jonathan Lamar**
PUTNAM COUNTY, GEORGIA
Son Jonathan helps Roger with morning chores on weekends and when school is out. Although he plans to attend college, the younger Lamar wants to continue helping with the farm in the future.

**45 Diane Caver**
CHILTON COUNTY, ALABAMA
Diane Caver picks okra in a field behind her family's house. Having worked on a farm since she was a small girl, she continues to labor on a regular basis in the fields and is active in the local church. She says of her husband, "Jessie had the opportunity to be independent and enjoyed the freedoms farming offers. He enjoys growing and selling his produce at the market." However, she notes, "The difficulties have always been in getting the monies to run the farm."

**46 Jonathan Lamar**
PUTNAM COUNTY, GEORGIA
Jonathan Lamar cleans the bedding in the milking barn for the next milking session.

**47 Luther Marable**
MARABLE FARM, THOMAS COUNTY, GEORGIA
Luther Marable inspects plants for insect damage.

**49 Blueberry pickers in the early morning**
VAN BUREN COUNTY, MICHIGAN

**50 Rosa Murphy hoeing**
BROOKS COUNTY, GEORGIA
After sitting out the afternoon heat, Rosa Murphy returns to the field and works until sunset.

**51 Freddie Samuel**
MARABLE FARM, THOMAS COUNTY, GEORGIA

**52 Toolshed**
HOLMES COUNTY, MISSISSIPPI

**53 Cotton module**
HUMPHREYS COUNTY, MISSISSIPPI

**54 James Davis Sr., James Davis III, and James Davis Jr.**
HALIFAX COUNTY, NORTH CAROLINA
The three generations of the Davis family—James Davis Sr., James Davis Jr., and James Davis III—have continued

to farm cotton, soybeans, and corn. "I love the outdoors and being with nature; watching crops grow every season has been a pleasure," remarks James Davis Jr. But he also complains, "These days for small farmers, there are a lot of headaches; the price of commodities is not in line with the price of fertilizers, seeds, fuel, and equipment. I lost more money in the last two years than in my entire life. The weather, price of cotton, corn, and soybean have all contributed to the losses. My father put four children through college on his farm income. He could not do that with today's costs."

### 55 Rodney, Wenceslaus, Edward, and June Provost
IBERIA PARISH, LOUISIANA

Rodney, Wenceslaus, Edward, and June Provost in a sugarcane field. Wenceslaus's sons, fourth-generation sugarcane farmers, will continue farming and plan on passing the business down to their children. The family works about three thousand acres, much of it leased and spanning two parishes, making them one of the largest operations in the area. Wenceslaus, who grew up farming, says, "Farming is in my blood; I love working in the field, and I would do it all over again. My kids love farming and that is why they will continue this farm, my grandchildren as well."

### 56 Charles and Anne Williams
SUMTER COUNTY, ALABAMA

Anne Williams helps her husband, Charles, pick peas and other produce during harvest season.

### 57 Edmond Clark
HUMPHREYS COUNTY, MISSISSIPPI

Edmond Clark is a third-generation cotton farmer. Because Clark's son has decided against taking over the farm, the nephew who currently assists him may eventually assume responsibility and keep the land productive.

### 58 James Davis Jr.
WARREN COUNTY, NORTH CAROLINA

James Davis Jr. continues the tradition of farming in his family. He grew some produce and tobacco, but after the federal government purchased his tobacco allotment, he began raising cattle. In order to save money to build a house on the land, he has had to find work off the farm.

### 59 Rodney Provost
IBERIA PARISH, LOUISIANA

Rodney Provost repairs and modifies parts for harvesters in the field. Because sugarcane farming is mechanically intensive, the Provost operation has its own repair truck that can be dispatched anywhere the large harvesters and transporters need to be repaired, thus reducing downtime in the field.

### 61 Jerry Singleton leading "Tat"
LEE COUNTY, ALABAMA

Jerry Singleton, eighty-one years old and a last-generation farmer, returns "Tat" to a grazing pasture after some light plowing. Singleton continues to farm twelve acres of produce, but uses an old tractor for heavier plowing.

### 62 Jerry Singleton plowing with "Tat"
LEE COUNTY, ALABAMA

Preparing the field for seeding, Singleton lightly plows with "Tat."

### 63 Cleveland Jackson
SAINT MARY PARISH, LOUISIANA

Sugarcane farmer Cleveland Jackson maneuvers his harvester through his fields. The old harvester constantly breaks down and needs replacement parts; long past its prime, the machine can barely keep up with the workload. Jackson vows "when the day comes that I can no longer fix it, I will be out of sugarcane farming." The price of a new harvester runs well over two hundred thousand dollars. Barely hanging on, the last-generation farmer continues to work his small holdings largely because of tradition.

### 64 Freshly picked yellow squash
MARABLE FARM, THOMAS COUNTY, GEORGIA

### 65 Willie Adams
GREENE COUNTY, GEORGIA

Willie Adams walks through his poultry house, checking on the chickens, feeding system, and temperature. Adams is a third-generation farmer: his father used the land for row cropping, and his grandfather grew cotton on the farm. Although his children will not actively farm, they will make use of the land by converting it into a tree farm.

### 67 Herman Lynch
MARTIN COUNTY, NORTH CAROLINA

Herman Lynch worked on his grandfather's farm for many years, until the older man died. Because of legal problems with the farm's deed, the land was sold to a neighboring farmer. Lynch now tends his grandfather's land as hired help.

### 69 Carl Whitehead
DOOLY COUNTY, GEORGIA

Carl Whitehead shows strain and frustration as the window of opportunity to plant his cotton seeds has come and gone. Having submitted his application for an operational loan, on time and as required before the planting season, he can only wait, even though other farmers who requested the same loans at the same time have already received their money and purchased and planted their seeds weeks ago. A fourth-generation farmer, Whitehead grew up working on his grandfather's farm and eventually took it over. He filed for bankruptcy in 1998 and will be the last generation in his family to farm.

### 71 Harold Wright
BLADEN COUNTY, NORTH CAROLINA

After designing a modification to convert his four-row sprayer to a machine capable of treating six rows at a time, Wright finishes some welding. "This modification will allow fewer trips through the field, cutting fuel costs and time in the field." Like other family farmers, he remembers better times: "At one time we were making a good living farming. The price of commodities versus the price of supplies has benefited large farms. Today you need big acres to survive; small farmers are a thing of the past, and yet they are important to the economy."

### 72 Warren James and neighbor
MACON COUNTY, GEORGIA

Third-generation farmer Warren James stops to talk with a neighboring farmer while checking some new plantings

in one of his fields. Among the crops James plants are peanuts, cotton, and soybeans. He and his cousin, who farms nearby, help each other during peak seasons.

### 73 Hendley Bryant
DOOLY COUNTY, GEORGIA

### 75 Toice Goodson
GREENE COUNTY, ALABAMA

A fourth-generation farmer, Toice Goodson works the eighty acres passed down through his family. In addition to cattle and row crops, Goodson experimented with alternatives, raising rabbits for both the medical and food industries. After some years of this, he sold off his rabbits and the associated equipment, as the operation required an increasing amount of his time during critical planting and harvesting seasons. Still, the last-generation farmer says that "the market is good for rabbits. With a processing plant in Arkansas, the company picks up the rabbits and sends a check the following week."

### 77 Roy Rolle
MARION COUNTY, FLORIDA

Roy Rolle is a third-generation farmer. One of the last farmers who has not sold his land to area developers, Rolle now has to drive his equipment through housing developments in order to reach some of his fields. Although the developers always offer to buy his land, he cannot think of doing anything else but farming. "Our farm land has been in our family for over one hundred years. I am hoping that I am not a last-generation farmer."

### 78 Cleveland Jackson repairing tire
SAINT MARY PARISH, LOUISIANA

Cleveland Jackson cleans a sugarcane transport wheel before replacing a patched inner tube that has once again gone flat.

### 79 Warren James
MACON COUNTY, GEORGIA

Warren James fixes a nozzle on his newly installed irrigation system, which waters eighty acres. "The irrigation system has helped, and having it is a plus with money-lenders. It allows greater flexibility in choosing what crops you can plant in that field."

### 80 Starling and Ervin Bell
MARTIN COUNTY, NORTH CAROLINA

Starling and Ervin Bell prepare to drive through their fields to note what must be done before planting season begins.

### 81 Earl Jones
BUCKINGHAM COUNTY, VIRGINIA

Earl Jones returns to his truck after checking on some young cows in a pasture. Jones, a third-generation farmer who works the same land as his father and grandfather, will continue the legacy by passing the farm to his son.

### 82 June Provost
IBERIA PARISH, LOUISIANA

June, the youngest Provost brother, fills out required paperwork that will accompany their trucks of sugarcane to the mill for testing of sugar content and weight. He

will travel from field to field filling out the paperwork as each truck is readied for the trip to the mill.

**83  Willie Head**
THOMAS COUNTY, GEORGIA
A successful litigant in the class-action discrimination lawsuit against the USDA, Willie Head searches the records of the Thomas County government to prove that his father was subjected to the same treatment by the local USDA loan offices.

**85  U.S. District Courthouse protest**
WASHINGTON, D.C.
Black farmers protest outside the U.S. District Courthouse prior to a hearing on their class-action lawsuit against the Department of Agriculture.

**86  Maxine Waters, Gary Grant, and USDA protesters**
WASHINGTON, D.C.
Congresswoman Maxine Waters and Gary Grant, president of the Black Farmers and Agriculturalists Association, lead a demonstration at the entrance of the USDA. Secretary of Agriculture Dan Glickman eventually agreed to their demand that he speak with them, meeting with a small delegation who spoke on behalf of black farmers.

**87  Arrest of USDA protester**
WASHINGTON, D.C.
A black farmer is arrested during a peaceful sit-down demonstration in front of the Department of Agriculture building.

**88  Gary Grant and John Boyd at Lafayette Park demonstration**
WASHINGTON, D.C.
Gary Grant, president of the Black Farmers and Agriculturalists Association, and John Boyd, president of the National Black Farmers Association, walk with a mule in Lafayette Park across from the White House during a protest by black farmers.

**89  USDA protesters**
WASHINGTON, D.C.

**90  Ralph Paige at "Caravan to D.C." rally**
WASHINGTON, D.C.
Ralph Paige, executive director of the Federation of Southern Cooperatives Land Assistance Fund, speaks on the U.S. Capitol steps during the black farmers' "Caravan to D.C." rally.

**91  Open session at Land Loss Summit**
DURHAM, NORTH CAROLINA

**92  Opening prayers at Land Loss Summit**
DURHAM, NORTH CAROLINA

**93  Stephon Bowens and Land Loss Summit participants**
DURHAM, NORTH CAROLINA
Stephon Bowens, executive director of the Land Loss Prevention Project, talks informally with black farmers after conducting a workshop on the Pigford Class Action. In August 1977 several black farmers led by Timothy Pigford of North Carolina filed a class-action lawsuit against

the USDA. These farmers charged that the county offices of USDA Farmers Home Administration (FmHA), now the Farm Services Agency, had systematically discriminated against black farmers for years and that the local, state, and national USDA offices failed in response to claims of civil rights violations. The local offices, directed almost entirely by local whites, illegally denied operating and disaster loans and other credit opportunities and benefit payments to black farmers. A final settlement was approved in April 1999, yet of the more than 21,000 claims accepted, just over 13,000 farmers have received their settlement checks. The Land Loss Summit was hosted by the Black Farmers and Agriculturalists Association.

**95  Shirley Sherrod and farmers meet with a congressional aide**
WASHINGTON, D.C.
Shirley Sherrod, a representative of the Federation of Southern Cooperatives, reacts as a congressional aide appears for a meeting instead of the congressman himself.

**96  Gene Cummings and James Marable**
THOMAS COUNTY, GEORGIA
Gene Cummings, a caseworker for the Federation of Southern Cooperatives, and James Marable sit in the waiting room prior to meeting with local USDA official about securing a loan that will keep Marable Farm operating.

**97  James Marable, USDA official, and Gene Cummings**
THOMAS COUNTY, GEORGIA
James Marable and Gene Cummings, a caseworker for the Federation of Southern Cooperatives, meet with a local USDA official.

**99  USDA official and James Marable**
THOMAS COUNTY, GEORGIA

**100–101  Joshua Davis**
HOLMES COUNTY, MISSISSIPPI
Joshua Davis waits to meet with a USDA official at the local office; the official never showed up, and Davis left after having sat for forty-five minutes.

**103  James Marable**
MARABLE FARM, THOMAS COUNTY, GEORGIA

**104  Cattle auction**
GREENE COUNTY, ALABAMA

**105  Doc Anderson**
VAN BUREN COUNTY, MICHIGAN
Doc Anderson, taking cover from a brief rain shower, keeps a constant vigil on the help he has hired to hand-pick blueberries on his farm.

**107  Madison Brown**
BUCKINGHAM COUNTY, VIRGINIA
Cattle farmer Madison Brown walks through a pasture on his farm during a severe drought in Virginia. The grass should normally reach Brown's hip by this time of the season.

**109  "Farm for Sale"**
HALIFAX COUNTY, NORTH CAROLINA

**111  Jeff Hawkins**
WARREN COUNTY, NORTH CAROLINA
Jeff Hawkins pauses at a fence surrounding one of his fields. Earlier generations of his family were sharecroppers, and he grew up working on a farm. After returning from military service, Hawkins started teaching and farming until the death of his father led him to move back to the farm. "The hog industry is in the control of big farms these days," he complains. "The prices run most of the little guys out of business. I am the last [private, family] hog farmer in Warren County."

**113  Eddie Carthan**
HOLMES COUNTY, MISSISSIPPI
Eddie Carthan owned the same farm that was passed down from his grandfather but had to leave farming when he was denied loans by the FmHA between 1983 and 1996. Thus driven out of farming by the USDA, he now runs a hardware store in Tchula.

**115  Louden Marshall with grandson Cullen as son Louden III walks away**
CUMBERLAND COUNTY, VIRGINIA
Louden Marshall ties his grandson Cullen's shoelace as his son Louden III walks toward the house. Only days before, Louden III indicated that he did not want to continue working the family farm, preferring instead to seek employment off the farm.
The senior Marshall is a third-generation farmer on land passed down from his grandfather. When Louden's father died, he took over on a full-time basis. "I like to farm, not a lot of money, just enjoy doing it," he says. "I had office jobs for some years but had the urge to be outside, be my own boss, and lead an independent life."

**117  Allen Gooden**
BUCKINGHAM COUNTY, VIRGINIA
First-generation cattle farmer Allen Gooden grew up outside Birmingham, Alabama, attended college, and then served in WWII in the South Pacific. In addition to working as a school principal, he has been farming since 1946. He purchased his in-laws' farm with money borrowed from them; after paying them back, Gooden purchased an additional sixty acres and started a tree farm. "It's the best thing that's happened to me," he says of farming.

**119  Roger Lamar in the milk house**
PUTNAM COUNTY, GEORGIA
Roger Lamar washes down the milk house after morning chores.

**121  Deserted farmhouse**
GREENE COUNTY, ALABAMA

# Acknowledgments

There are many people who enriched this project, sharing my belief that the story of America's black farmers is an essential part of our American history needing to be documented. I would like to express gratitude and appreciation to the following individuals.

In his eloquent essay introducing the photographs, Juan Williams gives great insight into the historic connection among the land, ownership, and black family farmers. Gary Grant, president of the Black Farmers and Agriculturalists Association, embraced the project early on, offering his knowledge and expertise. My friend Richard Pelletier's belief in the project kept my cameras fed. Lisa Pickoff-White assisted with final interviews. I am most appreciative to former sugarcane farmer Joseph Sique Jr. and cattle farmer Melvin Bishop, whose images are not shown on these pages, for their invaluable assistance with contacting farmers in Louisiana and Georgia.

Thanks also to Stephen Wrinn, director of the University Press of Kentucky, and editor-in-chief Joyce Harrison for their enthusiasm and support. Melinda Wirkus gave excellent guidance steering *Black Farmers in America* through editing, design, and production. Freelance copyeditor Jim Russo skillfully polished the text, and Stefanie Olson assisted in the arrangement of the images. Brady McNamara created a stunning, thoughtful design that embraces the photographs. My special thanks go to editor Gena Henry for her guidance and personal respect for the farmers, keeping foremost the dignity of their story as she helped to turn this project into a book.

Thanks to Dick Baghdassarian and Sebouh Baghdassarian at Pro Photo, Bill Pekala and Scott Andrews of Nikon, Kit and Gary Putnam and crew at Black & White Lab, and Frank Van Riper, Tom Lundy, and Adam Hong, who all participated at various stages in the preparation of the book. Thanks to Margaret Hutto and Rodney Williams, and a special acknowledgment to curator Nona Martin, the wind in the sails of the black American farmers project.

I would like to express my love and appreciation to my parents, Mary and Salvatore Ficara, who gave me my first Nikon camera and have always believed in and supported my interest in photography; my sister Annette Handley Chandler for her guidance and intuition; and Will Chandler for his positive reinforcement. Thanks to my brothers Sal Jr. and Richard for their support.

To my wife Nadia, who has endured my constant travel for newsmagazine assignments throughout the years, and for understanding and encouraging my drive to tell the story of black farmers even when it meant more time on the road.

Over the years, I have been fortunate to work with some of the best picture editors in the business at *Newsweek* magazine. I would like to express my appreciation and gratitude to Jim Kenny and John Whelan, who guided me in my early years with the magazine, and to Ron Meyerson, Dave Wyland (the coach), Guy Cooper, Jim Colton, Karen Mullarkey, and Amanda Zimmerman.

Thanks also to the White House News Photographers' Association for their creation of the documentary grant that helped finance this project. I am especially grateful to the National Press Photographers Association/Nikon Documentary Sabbatical Grant, which was instrumental in allowing me the time to complete the story of the disappearance of black farmers in America.